SHADOWBOOK
WRITING THROUGH THE DIGITAL 2014-2018

Miriam Rasch

DEEP POCKETS

Deep Pockets #2
Shadowbook: Writing Through the Digital 2014-2018
Miriam Rasch

Copy-editing: Matt Beros
Design: Leonieke van Dipten
EPUB development: Leonieke van Dipten
Printer: Groenprint, Rotterdam
Publisher: Institute of Network Cultures,
Amsterdam 2018
ISBN: 978-94-92302-23-6

Contact
Institute of Network Cultures
Phone: +31 20 5951865
Email: books@networkcultures.org
Web: http://www.networkcultures.org

This publication is available in a print run of 300 copies, printed on 100% recycled paper. EPUB and PDF editions are freely downloadable from our website:
www.networkcultures.org/publications/#deeppockets

This publication is licensed under the Creative Commons Attribution-NonCommercial-NoDerivatives
4.0 International (CC BY-NC-SA 4.0)

institute of
network cultures

MATTER MOVEMENT BY MARIA FUSCO	4
INTRODUCTION BY WAY OF ACKNOWLEDGMENTS (OR VICE VERSA)	6
A SMALL ORGANIC BANANA: *PHONOPHILIA* IN 12 SCENES	15
SHADOWBOOK	24
NOTES TOWARDS A SPREADSHEET NOVEL	38
THE POST-DIGITAL CONDITION	51
40: A FICTITIOUS SMARTPHONE ESSAY ON FRIENDSHIP	70
SUBLIMINALITATIONS	126
REFERENCES	150

MATTER MOVEMENT BY MARIA FUSCO

About ten years ago, I was working with a professional transcriptionist. I employed him to render an interview I had conducted with a performance artist into concrete words on a page.

I've just had to put the pen down. That's the fifth consecutive day this has happened. I've picked it up and am beginning again. I can't type my own life out. It's too important. I went out and bought myself a nice big fat shiny fountain pen, three packets of black ink cartridges (I don't know how long each one will last, so thought it best not to take any chances) and a leather-bound black journal. Luxuries I know, but necessary all the same to me.

He emailed me to ask if we could speak on the telephone, to clear up the meaning of a specific phrase that re-occurred throughout the interview.

When I was growing up, school was all about the neatness of your handwriting, the regularity of the looped characters within faintly traced pink feint. Children were never ever allowed to write with a pen; that was only for grown-ups. I thought this was because what adults wrote was so much more important than what we did that it had to be preserved in pen, fixed in ink, permanent on the page, like an oath. Our scribbling attempts were consistently pale, indefinite, tentative, dreary across the jotter page.

Towards the end of our phone call, he said he needed to tell me something and asked if I had time to hear it. Of course, I said, yes.

One day we all had to write: 'Today I enjoyed feeding the hamster in the classroom.' We didn't have a hamster in our classroom. I asked the teacher why we had to write a lie. She locked me in the stationery cupboard. When she eventually let me out, my fingertips were covered in tiny paper cuts.

He told me he was writing his life story, but that he had to write it by hand, longhand with a pen and paper, because to type it would be demeaning; depicting it in the same way as he did other peoples' words.

My hand hurts. I wonder if I'm pressing too hard down on the page of the journal... The middle finger of my right hand has developed a hard ink-stained bump near the nail. It's ugly. The page behind the page I've just been writing on looks like it's stippled in brail, almost punched through with the pen. But these words are so important. I can't keep
s
t
o
p
p
i
n
g

Who does the experimental experiment with?

Maria Fusco is a Belfast-born interdisciplinary writer. Her work is translated into ten languages. mariafusco.net

INTRODUCTION BY WAY OF ACKNOWLEDGMENTS (OR VICE VERSA)

> 'I wanted to clear my head. I wanted strangeness and coldness and precision.'
> Helen Dewitt, *The Last Samurai*

Plain and simple: here I present five experimental essays and one exposition (for lack of a better word) which are all in some way an example of research through literary writing, research *into* writing *by way of* writing. Writing, in this case, about the digital and through the digital. Now I must state right away that when I talk about writing, I talk about words, letters, sentences and style; about language, human language and written language, even though the last of the essays included here originates in voice and audio. This might mean that my research has found a more or less natural ending, dissolving into sound. In any case, this booklet in itself may be seen as such an ending too.

Of course, nothing is ever plain and simple. 'How do we write when we write online?' was the question posed by Orit Gat in a project that stems from 2014. The responses to that question are manifold: Gat mentions the longform and the short form (like blogs or tweets), online writing is said to be networked, personal, speedy, chaotic and distracted, structured into semi-coherent forms like the listicle, written for as many readers as possible or just for yourself. 'How do we write when we write online' is the same question that haunts my own research and writing. In 2014 I wrote the first essay included here, 'A Small

Organic Banana: *Phonophilia* in 12 Scenes', which is a direct inquiry into that question. I was invested in the issue also before that. In fact, 2018 marks the ten year jubilee of my blog – which is now defunct as a *blog* blog and functions mostly as an announcement board or ad pillar, which is the way of so many blogs, I guess. I blogged (was a blogger) for around five years. The blog was about everything at first, but quickly became focused on literature and philosophy. It was always an investigation into 'the blog', too; into, one could say, writing online. After a couple of years the genre got exhausted (and so did I) and I kicked the habit of blogging by writing the 'banana essay'. The question, however, never tired.

One shouldn't, I believe, just write about writing without letting what you write about influence your own writing – 'eat your own dog food' as the computer programmers say – so over the years I've kept trying to experiment with different ways of writing about the online in order to find out more about writing online. Or maybe it's not just about writing online anymore. 'Online' almost seems an old-fashioned concept; since 2014 there have already been so many new (social) media, channels and platforms where writing is happening and this writing has seeped into places that aren't online per se. Now we talk of post-digital writing, which can take place online, but just as well in an offline application, or in a paper notebook, in a printed volume, in the park. Let's say there are many spaces where we write in post-digital times. And in these spaces, we are writing *through* the digital.

While we all write through the digital day in, day out, the answers to the question of how are still scarce. Sure, we all know the familiar positions by now. There are the doomsayers with their claims that people nowadays do

not and cannot write anymore whatsoever, they don't know how to use punctuation or capitals, let alone simple spelling rules. It's because they don't read that they can't write, and they don't read because, basically, they're stupid. All they do is eat images, whether moving or not (preferably moving). Then there are the 'positivos' to use a beautiful Dutch word, who never tire in their conviction that we write all the time, it may not be books just chats and tweets, but writing is writing and by the way that's not misspelled but creatively spelled, we're witnesses to a beautiful peak in the constant renewal of language! Sometimes it is said: now it's possible to add a hyperlink and a video to your essay and that means writing has become interconnected. Most people are plainly not interested at all.

The question of how language moves in digital spaces, to rephrase slightly, remains unanswered. What do digital technologies *do* to language and the way we use language? To the way we talk about ourselves, talk and write to others, in order to remember and tell stories, or to flirt, to work, to mourn?

If a question goes unanswered, one should set out in search of an answer. So that's what I've been doing. In 2017 this quest resulted in the publication of my book *Zwemmen in de oceaan: Berichten uit een postdigitale wereld* (*Swimming in the Ocean: Texts from a Post-digital World*), published by the Dutch publishing house De Bezige Bij. The book consists of twelve essays about the internet, about literature and philosophy, and about me and us, our lives that now unfold themselves post-digitally. Of course, the essays are also about language and quite explicitly ask 'how we write when we write online'. The essays are as much about form (the listicle, the blog, the excel sheet) as about affect (discipline and habits,

distraction and laziness, disembodiment and pleasure). But the essays themselves are still that: essays. As a research result that still counts as pretty wild: writing a book for the general public and not for your academic peers. But it's not eating your own dog food.

Shadowbook, then, is my dog food. Contained here are mostly what I call experimental essays, a genre with the public appeal of translated poetry. They are debris. Some of the pieces were written as a way to let off steam, get out all the clutter before the crafted essay could take form. Some were written for the book but didn't make it in, on account of looking too scruffy compared to the it-crowd. Some originated in a notefile with phrases and quotations that I would have posted on Facebook or Twitter if I wouldn't be afraid that people might think I was suicidal. *This morning, for the first time in a long time, the joy again of imagining a knife twisted in my heart. Emotion stripped of emotion. I am an innocent child, since I am dying. I have never liked time very much.* This file was called 'Shadowbook', a sobriquet I've kept ever since.

I already mentioned the first of these pieces that I wrote back in 2014: 'A Small Organic Banana: *Phonophilia* in 12 Scenes'. For a long time I had been bugged by easy dismissals of the online, especially by philosophers who liked to critique the superficiality of the internet in the most superficial manners possible. Instead of writing another article criticizing the critique of the critics, I decided to set the example by writing something thoughtful about life online, better yet, something capturing all its beauty and ugliness, all the ambiguity, shallowness and depth. I decided I would write about the most intimate, confusing and fun manifestation of it: the smartphone and how it channeled desire, and,

sure, sex. I knew it would work only if I put myself on the line. The piece would set a lousy example if it was boring or badly written. It would make no sense to write an aloof, academic, quasi-intellectual tl;dr paper. 'See!' one might say, 'In the end all returns to words on paper and there are many of them.' Instead, I returned to the more historically inspired means that seemed to fit the internet age very well: a fragmentary structure propped up with quotations, just like on the web, with relatively short, numbered paragraphs like a listicle, using personal revelations like on Facebook (back then, people still actually wrote personal stuff on Facebook). The essay ended up winning me the Jan Hanlo Essay Prize in 2015 and that helped get the contract for *Zwemmen in de oceaan*.

> Here are my first acknowledgments: thank you to the Jan Hanlo foundation and to De Bezige Bij.

The notefile entitled Shadowbook already existed back then. Mostly it consists of phrases I've read or heard somewhere and that speak to my dark side. *If he didn't think of death, he thought of nothing.* The dark side that doesn't really get its due on the social networks. Which is a bummer, I think. I would like to read stuff like this from people, actual people and not just quotation bots. Still, I didn't dare to do it, so why would anyone else? I decided to go full on experimental and turn Shadowbook into a story, or something that didn't fit into a genre yet. The genre of Facebook updates from 'the other side', as I wrote somewhere. I submitted it to *The Torist*, a literary magazine for the deep web, hosted on Tor and filled with wonderful and odd texts written through the digital. The introduction to the issue stated that 'Shadowbook' 'blurs the lines between short story, flash fiction and prose poem', which pleased me, since I was a bit worried still about getting the reputation of being suicidal. But in

stories, fiction and poems, especially those that are short, flash and prose, everything is allowed.

> So thank you, Torists, for publishing this dark hybrid of a text.

Researching the history of the internet and its social implications, I kept coming back to the theme of bureaucracy and administration, which to me is exemplified in the spreadsheet. This may sound like a big leap from the updates from the dark side, but it's not. The spreadsheet in itself is some kind of shadowbook and Excel is for many people like 'the other side'. I often had fantasized about writing a spreadsheet novel that would deal with rows and columns, *and* with nightmares, lust and power. I started writing an essay to include in my book, a seminal text that would connect the internet to bureaucracy, the 'backside' of code to database interfaces like Excel. Some weird shit came out. Not surprising, since it is weird shit that the spreadsheet harbors, as much as it wants to hide it. I called the essay 'Notes Towards a Spreadsheet Novel', because that's what it was in the end. The novel of course never came into being. I had to start my research all over. I dumped bureaucracy and wrote another essay on the spreadsheet for the book. The weird shit of the 'Notes' is the debris of that essay, but a debris that came first. Isn't that often the case? Isn't that the point?

> Many thanks to Dirk Vis from *De Gids* who read my 'Notes' and immediately published it in *De Internet Gids*, before I even knew whether it was even a final version and of what.

In the mean time, I continued my more conventional work on contemporary literature, thinking about the themes that seemed to prevail in more mainstream literary productions

written in the post-digital era. Without being overly or obviously post-digital in their style or format – although some of the more avant-garde characteristics of post-digital writing had started showing up there, too – I sensed that some of these works dealt with a meaning of 'post-digital' that was rather existential than aesthetic. 'Post-digital' does not only convey the state of arts, design and media being digitized, but humans as well. How to deal with your own digitization is the question that roams in the background.

> 'The Post-digital Condition' was published in *Zwemmen in de oceaan* and was translated by Nadia Palliser for the INC Longform series.

By now I started to think actively about taking up a digital form and writing in it, *through* it, combining the existential and the aesthetic implications of the post-digital. After the listicle, Facebook and the spreadsheet, what should come next? Not much doubt there: back to the smartphone. If you set out to write something knowing it would be read on the screen of a phone, what would happen? What forms, words, styles, affects does the little screen demand? Probably fragmentation, again, and brevity and sharpness, but also a sense of being connected, belonging to many different groups or wanting to, being close to everyone including yourself, or wanting to. I already knew I had to write about friendship some day (another major annoyance was the way in which philosophers – these philosophers again! – write about online friendship) and this was the perfect outlet. All your friends are locked up in there, and all frustrations are reflected in the screen just as well. It would be intimate and lonely at the same time, like friendship is. Like life is at (almost) 40. *Borrowing scenery*. I called it '40: A Fictitious Smartphone Essay on Friendship'. Fictional essays: another non-existing genre

and another attempt to answer the question how we write when we write online.

> Again, I have to thank Dirk Vis, with whom I now edit an experimental ebook series for *De Internet Gids*, which also accommodated this sibling in the *Shadowbook* saga.

The last essay, just as fictitious or real as the others, in a way is a goodbye to the question. The thousands of words of 'SUBLIMINALITATIONS' are written down, but they came into being in my lungs, through the throat, on my tongue, as I spoke into my phone's recording app, first in Dutch, then in English. Later followed the endless editing to make it into a proper written text, but in a sense I would still want the words to be heard, listened too, instead of read in silence. Ideally silence would be maintained, but in a different way. I imagine someone sitting on a train with their headphones on, looking out the window but with an inward gaze, retreated into an inner silence on the cadence of the words, the voice. Maybe that's not how we listen anymore; we get short voice messages, skip through playlists, need our podcasts to be entertaining. We might not be reading as much anymore, but another point is this: who actually listens? I hope my reader-listener might still have an inner silence to retreat to. *I look so much like myself, people always mistake me for my own doppelgänger*.

> Here I have to thank Sonja Schulte, who set me on the track of audio as a way to write.

There you have it: five years of writing through the digital. Looking back I see all that's changed and all that's stayed the same. The internet has changed and I have stayed the same. It sounds like something an older couple might say to their therapist, and I guess we are kind of

in an old relationship with the internet now, and might need therapy. Traumas are shared, always: I might like to think that the recurrence of a theme like repetition is my own little shibboleth, but it is one that I share with many other people and therefore with the web (the web is still human-made, after all). All these writings in the end muse about some trauma (in the negative *or* the positive sense), about 'the other side', about the shadows where we can't see the other, although the other is there too, always. I hope you take pleasure in my share of shadows.

> Maria Fusco offered me a beautiful piece that blurs the lines between short story, flash fiction and prose poem – I am thrilled that there is another voiced to be heard in this volume, true to what the internet is or should be. Thank you! I also have to thank all the other kind people with whom I had the pleasure to talk about writing in the digital sphere over the past years, and who insisted I should work on an English publication; without their encouragement I wouldn't have dared to do it.

Many thanks too, to Matt Beros for copy-editing, Leonieke van Dipten for the design, Geert for letting me publish my own INC publication, and the Dutch Foundation for Literature and the Van Doesburghuis for the residency that made this publication possible. Theo van Doesburg, or better yet, I.K. Bonset, is with me in spirit.

The universe is finished.

Here's to you.

May 2018
Rotterdam, the Netherlands

A SMALL ORGANIC BANANA: *PHONOPHILIA* IN 12 SCENES

1.
'The Big Dipper!'

With one hand he let go of the wheel of his bike and he pushed his index finger into the sky above. 'Your phone number resembles the Big Dipper!'

I hadn't the faintest idea what the Big Dipper looked like, but hey, I was sixteen, it was 4am on a Saturday night and the boy I was riding home with compared my phone number to a constellation of stars. It was almost the same as reciting a love poem.

I can't remember whether he ever called me but since that moment I do recognize the Big Dipper without hesitation. 1-9-6-4-8.

2.
This was a time when phone numbers consisted of just five digits (in the villages surrounding my home town they even had just four), which you learned by heart like a mantra. Whispering the numbers to yourself seemed to bring the boy closer, as if he came to life by your breath. Now I don't even know my lover's phone number by heart. Sometimes I start to practice, just in case of emergencies, trying to make it into a little song like I used to. But emergencies are too rare an occurrence to actually remember the sequence.

I'm not nostalgic when it comes to phone numbers, not even when I think about the romantic practices that will never take place again. Like the other guy who went through dozens of pages of the Culemborg phone book, trying to find my number. We were registered under my mother's name, which he didn't know. He did know my

address, so he traced line after line, page after tissue paper page, until he found it. And could call me.

That was twenty years ago and everything about the situation has changed. Not too long ago, you could say: just go online and type the person's address in a digital phone book and there it is, that is the number you are looking for. But who uses a digital phone book? Who even has a landline phone that is registered in such a database? Who even has a landline, period? And why would you want to look up a phone number anyway? It's awfully obtrusive to just go and call a girl, why don't you just add her on Facebook and start a chat?

3.

The other person is so close, a few clicks and there he is, that the game of longing and seduction is lost. That is, at least, what the philosophers say. Byung-Chul Han describes our time as being characterized by a constant availability of everything and everyone: 'Unmediated enjoyment, which admits no imaginative or narrative detour, is pornographic.' A boy who traces the Big Dipper in the starry night so as to remember your phone number – that's the real thing. Chatting away on Facebook while scrolling through hundreds of pictures – degeneration.

Surely, desire in the age of Facebook can just as soon take on the guise of obsession, which might then from one day to another, through overstimulation and unending nourishment, turn into immediate boredom. There is no quest anymore, no fear of the other not knowing who you are, no absence. The other is always within arm's reach, ready to be scrutinized from every possible angle – you can read the articles he reads, listen to the music he listens to, get to know the people he knows. The distance to the object of desire has never been so short and that's precisely why true love and lust diminish. In her sociology of love, *Why*

Love Hurts, Eva Illouz describes the feelings one might get from a Facebook-chat as fictional, since there has never been a 'real' interaction. Moreover, the person on the other side is 'virtual' and in the end remains 'absent' and 'nonexistent', and therefore somewhat phantasmagorical.

For there to be something like 'true love' distance is required, says Han, something you cannot grasp, cannot see, something that makes you sense what the other is, namely: an *other*. 'Not enjoyment in real time, but imaginative preludes and postludes, temporal deferrals, deepen pleasure and desire.' Such imagination however, is fading, and so-called image culture is to blame. All of the pictures, emojis, videos; they're in your face, digitally produced, and therefore literally without a negative. This genre, Han writes, 'belongs to the order of liking, not loving'.

4.
Drawing the Big Dipper in the night sky, isn't that the ultimate *image* –wordless, loaded, a composition of light and darkness – the last thing to compare to a love poem? Can we even keep up the difference between the 'real' and online? Medium and reality have become so intertwined on all levels – whether it's language, perception, our senses – that divorcing the two is a fiction in itself, more fictional, I'd say, than feelings aroused by a virtual person.

The world is constantly shifting on all these levels, is what the protagonist from Ben Lerner's novel *10:04* would say. For him, the city has already been drenched in an extra layer of meaning for years, a layer that originates in his smartphone. He states rather matter-of-factly: 'As I read I experienced what was becoming a familiar sensation as the world was rearranging itself around me while I processed words from a liquid-crystal display.' Messages about love, suffering, life and death reach you through this blue-lighted screen, but that doesn't make them less 'real' than a

rendezvous arranged without using a device.

Those messages are *read*, first and foremost, because whoever would call anybody anymore? In that sense the world is built up more and more from language, rather than from images.

5.

A couple of years ago, I spent a summer on my iPhone, which through various social media brought to me the object of my desire. My coincidental geographical location didn't matter. The iPhone was glued to my hand, even if I crossed the border. At an ever-increasing pace I exchanged messages with J., on Twitter, on Last.fm – a website for keeping track of the music that you listen to – and Facebook, text message, WhatsApp, and, for months on end, via the digital Scrabble app Wordfeud.

How does something like that start? Well, you follow each other on Twitter and read along as the other's life unfolds on your timeline. A funny comment is followed by a direct message, you give a clever riposte, you Google one another, you read up on him so to speak, start to write just in keywords so as to get one more reaction, the messages shorten instead of lengthen, and within a few weeks a construction of idiomatic words, sentences, allusions, written sighs and dots is erected. Would philosophers such as Han and Illouz ever have experienced such a truly mediatized love affair?

6.

I've never been good on the phone. Calling a boy?! Forget about it. Fortunately the smartphone is a computer that happens to have a call function. Chatting is more important, whether it's through WhatsApp, Facebook or Twitter.

In that way the phone is still a junction that makes love possible, as it's always been. It can even become the

personification of the loved one, with all the pain that entails. The landline at times could seem like a hostile entity, not ringing as it was, while the boy had done so much as compare your phone number to the Big Dipper. The plump appliance that was shared with family or housemates was located in a cold hallway and its line was always too short. You'd press the earpiece, which to be honest was of grotesque proportion, to your ear but the harder you pressed, the longer the distance between you and him seemed to become.

In his 1930 play *La voix humaine,* Jean Cocteau tells the story of a woman receiving a break-up call: on the other side of the line a man puts an end to their relationship. I always associated those kinds of impersonal ways to break up with the cell phone, but apparently that is not correct. The cell phone does seem to make the humiliation worse, because there is the option to use nothing more than a text message.

To the woman on stage the distance produced by the phone call is enough of a humiliation. She longs for physical interaction: 'You used to see each other ... One look could make everything alright, but with this device what's gone is gone.' Slowly, she wraps the phone line around her neck.

7.

The telephone has always brought pleasure, too. The Hungarian writer from the interbellum period, Dezső Kosztolányi, describes the morning ritual of his marvelous hero Kornél Esti: 'In the morning when he woke up Esti had the telephone brought to him in bed. He put it by his pillow, under his warm quilt, like other people put the cat. He liked that electric animal.'

The electric animal in Esti's bed is a landline, of course. The smartphone has even more going for it to become a lover itself; it's always there with you, it lies in bed on the pillow besides you, it nestles in your pocket, ready to

vibrate, right next to the loins. It's like a child for whom you develop a sixth sense, you keep track of it from the corner of your eye and when it drifts off out of sight you follow up on all the regular spots to find it again, quickly.

Yes, it is like an animal that is caressed, that is nourished, an electric animal that you turn about in your hand, just to feel its contours and the possibilities that are contained within it.

8.
Telephonic love rises to a peak in Spike Jonze's film *Her*. Theodore develops a truthful romantic engagement with his operating system Samantha. This is not a dystopian movie (at least not to me) – rather it shows that love for a system that has all the characteristics of a human being, except for physicality, is human love. Who would ever dare to call Theodore's feelings fictitious? And the relationship with Samantha as 'virtual', 'absent' or 'non-existent'? *Her* tells us about *programmatic* love.

The first time that I felt my phone turn into a substitute for the one I loved, or rather turn into the centrifugal point of my desire, was with K. I met him at a party, stayed the night in his apartment in the middle of town, and spent the following days terrified that I would stumble into him unprepared, or, even worse, that I would never see him again. I didn't have his phone number; something like social media was still budding somewhere on the web that required calling in through a landline. After a couple of days living in the negative, to paraphrase Han, I wrote him a letter. 'I'm terrified of stumbling into you unprepared, or, even worse, of never seeing you again.' I signed it with my mobile number, left it in his postbox and began waiting.

The mobile phone I owned back then, eight years before my iPhone-driven summer of lust, had a two-color screen and enough memory to store five text messages. I copied

some of the messages that K. sent me in a text file that over the course of the years has disappeared in the quicksand of my hard disk. I can't remember the words, although language was all we had. The most important were the punctuation marks, the difference between one, two and three dots. K. was the one who taught me how to desire in 160 signs. We only met two or three times after that night, but it didn't matter. My phone *was* K. I liked the electric animal.

9.
Complaining about new technologies has always happened. Already in 1900 the Dutch writer Louis Couperus, in his novel *The Hidden Force*, had Eva complain about how the telephone killed all the fun: 'people no longer saw each other, they no longer needed to dress up or get out the carriage, since they chatted on the telephone, in sarong and linen jacket, and almost without moving'.

A new technology takes away another scrap of our humanity, until there is nothing left. We don't even need to dress up – see how civilization erodes! Another more tragic example comes from the story 'The Sandman' by E.T.A. Hoffmann, which is from 1816. Nathaniel falls in love with Olimpia, whom he sees only from far away. When he finds out that his obsessive love is directed at a robot, he throws himself of a tower. Dead.

What these stories tell us is that technology which becomes too human makes us less human ourselves. But what if Nathaniel would have tried to talk to Olimpia sooner? Wouldn't he be able to continue feeling a deep, truthful love for her? Isn't it the closing of the border between the technological and the human, between distance and nearness, between death and love, which finally results in the downfall of Nathaniel? Whoever saw *Her* has to admit that such borders are more porous than we might have previously thought. By the way, their

programmatic love doesn't end well either. Seduction and desire, only rarely do they get a happy ending. Technology has nothing to do with that.

10.

Am I another pathetic nutcase if I describe my phone as the substitute of my lover? I don't think so. Technology has always been inextricably connected to humans and human relationships. That is not to say that it always leads to some kind of progression. As Ben Lerner puts it, something happens in the balance of things which makes the world rearrange itself. The device in your hand, against your thigh, on your breast and in your purse is an integrated part of your being. Sure, it's a machine, a robot, but to quote Nathan Jurgenson, 'it is still deeply part of a network of blood; an embodied, intimate, fleshy portal that penetrates into one's mind, into endless information, into other people'.

Embodied, intimate, fleshy: might the smartphone channel desire and pleasure after all, let *phonophilia* bloom? Isn't it possible that the wordiness of mobile communication, the ongoing practice in the use of the written word, turns out to be precisely the savior of the game of seduction? My summer of iPhone lust made me realize that real time pleasure can actually transcend the genre of 'to like'. Whereas K. and I had played checkers, the game that started with J. took on the complexity of chess. The transition from text message to Twitter meant a transition from 160 to 140 signs, from paid to free, from five messages each time to fifty. We played Wordfeud as if our lives depended on it – word after word after word.

LLAMA. LEGS. STIPULATE.

By playing the game – the one of Scrabble and the one of the direct message – we taught each other the art of seduction, I can't call it anything else.

Or, maybe. The art of titillation.

11.

Smartphone sex doesn't have a lot to do with porn or webcam sex. The latter is a matter of imagery, the former of language. In the imagery of webcam sex there is no negative, as Han would have it, everything is exposure, pornography. In direct message sex everything is language, everything is dots, everything is wordy sighs and groans, everything, everything.

'For a year already I hadn't had any telephone sex,' writes Arnon Grunberg in a column. 'I texted my girlfriend: "Shall we have some telephone sex? Tomorrow or tonight?"'

She's fine with it, but it won't take off. 'After a while she said: "Hold on, I will get a banana." I heard her go down the stairs, opening and shutting cupboards. "What kind of banana is it?" I asked. "A small, organic banana."'

This makes me laugh. Whoever would think of calling in the first place? Try to imagine however that your lover sent you a message, a written one, through the private channel of a public microblogging service: 'A small, organic banana.' Doesn't it sound like poetry, the poetry of lust?

12.

Love is, as Han says, seeing the other as other. But also: seeing the otherness in what the rest of the world deems merely normal. The Big Dipper in the five accidental digits of a phone number, two (not three!) dots to end a text message, a Wordfeud word being connected to yours and simply, your own phone, the personification of him.

My phonophilia romances all ended badly. I was left with dozens of messages and broken off Scrabble games. I misunderstood the words, I didn't know how to play the game at the top level. Language can be dangerous. Like love, like a love poem.

2014

SHADOWBOOK

3 hrs
Fuck you sun. I'll stay in bed the whole day. I work too hard, I drink too much. I drink too much and I start smoking like a chimney. And once I start smoking like a chimney, I can't be bothered to get up again and again for every cigarette, to walk again to the balcony door. So I put the ashtray on the table. When it comes to that point, the sun can just fuck off in the morning.

The sun rises from the left hand corner of the bedroom window and moves up with a faint bend. The windowsill is one axis and the frame the other; growth is inevitable, although the curve flattens slightly as time moves on.

If I stay in bed long enough, the sun returns in the reflection of the windows on the other side of the street. Steep and inescapable it shines.

March 27, 2012
Why was your contract not extended? Don't know, the numbers below the line said it couldn't be done. The numbers have spoken? Yes. Which line? The one on a bloody Excel sheet. I don't believe you. Neither do I. Then why wasn't the contract extended? Well, the present period is one of administrative numbers.

I had a brilliant idea. I became the Human Cat. I would sit on the windowsill enjoying the sun. I would stretch out on the edge of a soft blanket and then curl up on that same blanket, into a soft, fluffy ball. With my limbs spread out I would refuse to be put in

a box and I would escape from the balcony. I would make noises with my throat and put my vowels on the tip of my tongue. I would change into a glorious animal. I had a white woolen sweater, a white woolen blanket, white skin and white hair; I would be a white cat. I would let them stroke me and in the end I would crawl away behind the old boxes in the attic. Mon cerveau se doit reposer, I would say.

5 hrs
I quit design and became accounts. He said: 'To be an accountant in the age of spreadsheet programs is – well, almost sexy.' Now I'm project manager, meaning I don't manage people, but Excel sheets. I'm right in the middle of a dynamic field: the project. What's it about? It's my responsibility, that's all there is to it. The Excel sheets are uploaded to TopTool each month and accounts checks if things are okay. They are, so far. I am a producer of normal behavior.

1998: My First Job
In front of me is a pile of files: international train trafficking in three languages. Switches, signals. Security, securité, Sicherheit. Raise the lid, put the first page of the file on the glass plate, lower the lid and push the button. Look up to the ceiling, away from the light. Turn one quarter towards the computer screen.

Control, controllé, Kontrolle, rolle, rollé, rol.

Type F for French. Enter. Turn back and raise the lid.

Later I became in-house designer, then accounts (accounts is something you are, you say: 'I'm

accounts'), then project manager. Also: assembly line temp, shop assistant. J'aime bien la production, deliverance, ticking off, enter.

25 mins
My mother says he is a nice someone. Or, while watching television: that was an interesting someone. It's the reason I work here. Job offer: BRN is looking for someone. A someone.

I want people to say: now that's someone, yes, *A* someone. Identify with a someone who you are yourself, being a someone yourself.

Now
Not sleeping I think of work. Thinking of work I cannot sleep.

To sleep I think of flowers, more precisely I picture a field of grass about eight inches high (stop! do not think: two bums high, because no one is here and no one is welcome), with dandelions and daisies, flowering trees made of shadows. Apple trees or cherry trees, hawthorn? – the shadow of leaves, flowering their shadows above my head very lightly, my face speckled with shadows, with flowers, my body in the grass, on a field of grass with dandelions and daisies growing out of my eyes. My eyes speckled with sleep.

22 hrs. Edited
He came in and started talking immediately. 'It all began with coffee. You know, we have three breaks a day, two shifts, and everyone takes a cup before starting the line. That's eight coffee moments a

day, to be multiplied with tens of people. All those cups disappear into the bin. Nijensleek is one of eight areas in the Netherlands that is home to the root vole and the root vole happens to be a species of communitarian importance! This creates a responsibility that the board is unwilling to take.'

I wanted to say, I'm accounts, but I wasn't yet. I didn't know how this guy ended up at my desk. So I nodded.

'In the kitchenette I unearthed some old coffee mugs that had probably been lying around since times before the coffee machine. I cleaned them, decorated them with stickers spelling the names of my co-workers and handed them out. I told them about the root vole. "Who ever saw a root vole around here," I asked. But no one responded. "Some call him the Dutch Panda, because he's such an endangered little fellow since the reclamation. In Vledder too, he is uncertain of his livelihood, thanks to mercenary industrials!" People were used to hearing me talk about dad like that.'

The board, I wanted to say and nodded.

'A whole family lives in the ditch behind the building, where Nijensleek is cut off from Parallel Road. Right there, in the reeds! They eat grasses and herbs that used to grow out there, but which have almost disappeared because of all the rubbish we produce making our Fried and Frozen. I throw around some extra greens, but it's hard to find something they like. Once I used my mom's parakeet's food and I actually saw something move: it was the root vole! Exactly what you would imagine a root vole to look

like: a small, fluffy ball a couple of inches long, beautiful brown fur and a pair of cutesy petite ears that vibrated in the air.'

On my screen I had brought up a picture of a root vole. He nodded.

3 mins
We change the input as many times as we need to make it right. Until the guinea pig is saved. The rabbit? Wasn't it a guinea pig? Oh, the root vole. Saved, right. They're fed, fed up, fed into the system! How many root voles are to be saved, are savable? A couple, a few, some. I love making things right like I'm a mob boss, getting someone's ass saved. A someone or a root vole or a family of root voles.

I am a banker in a dynamic field. Not a real banker, or, why not? – just as invisible and mobbed-up, just as attached to administrative numbers. How can one approach that which isn't there, without changing it into something that is?

Now
The formula of the Excel sheet: You change one thing and everything else changes alongside it. Is that determinism or rather chaos? All is random – which number you choose doesn't matter, because it will add up anyway. Two different numbers can actually be at the same place at the same time. Potentially, yes, they all exist simultaneously since it doesn't matter anyway. No, wait, they cannot precisely. The dark matter of formulas.

The only thing that's certain is my responsibility.

The shadows are stretching. Whether it's light or dark doesn't really matter.

April 2, 2015
Throwback Thursday: one year ago I threw up in the waste bin in the Intercity Direct train. I put on my sunglasses because I knew I should have sat somewhere else. Closer to the toilet? Yes, closer to the toilet. But I couldn't walk any further, I had to sit down. On the platform I had walked up to the end, to the spot where you look out over the water with the ferry and the museum on the other side. One mandarin in orangey fibers. All my fibers. Right, that was the mandarin, I thought. Earlier, in the office bathroom, other things – such as what? I didn't eat lunch, then one mandarin. All is out.

April, no time to be wearing sunglasses, let alone putting them on in the train. The sun was shining, that much is true. I was in my summer coat, it wasn't cold. Sweaty weather. Glad to get on the train – the bathroom could wait, it wasn't needed anymore. All is out.

I tried to catch it in a paper tissue; the tissue immediately dissolved in my hands, my catching hands, throwing it into the waste bin next to the seat. Sunglasses, the light out of my eyes (entering in the convent). The ticket man, the people. When is one ever checked? I hid behind my dark glasses. I'm a rock star. Rock star at 4 pm. Wish I had drunk too much.

Then the woman beat the pigeon to death with a chain lock.

8 hrs
Fuck you sun. I'm not getting out of bed. 'Come on, we gotta catch some sun' – 'come on, we gotta go have a drink' – 'come on, we're gonna enjoy ourselves'. Fuck you, but I have to.

I had to. My nephew is eight years old, you can't deny him anything. I'm the cool auntie who works hard and has a lot of money. The actors walked around in the audience singing 'par-ti-ci-pa-tory socieieiety!' And us too: 'par-ti-ci-pa-tory socieieiety!' One for all, all for one.

The student got up and spoke. Just a minute ago I stood smoking behind the station, I was way too early of course. You don't want to get out of bed, and then when you do it's too early. In front of me, you won't believe it, a sparrowhawk attacked a pigeon. Sparrowhawk – the name popped into my mind immediately. Dormant knowledge always comes in handy some time. I do not know more than this name. How the sparrowhawk kills its prey, for instance. Who or what its prey is. I kicked in the direction of the birds. The sparrowhawk flew up and attacked again, hit the pigeon with a full body check, whirling it around under its claws. I raised my arms, tried to make myself look bigger. I once heard you should do that when you encounter a bear, but not a grizzly bear. The sparrowhawk flew away behind my back, leaving its prey, the pigeon, behind.

A woman arrived, drawn by the bird noises. Then she beat the pigeon to death with her chain lock. 'He's still alive,' I said. The pigeon breathed in a gagging manner, it wrenched on the pavement as if its wings

were bound on its back. The sun blinded him, possibly. There was the woman again, chain in hand. Let him try to die by himself, I said. He did, the pigeon did. I put my finger into existence – it tasted of nothing.

March 10 at 10:34 pm
Who I was when he died: 25, a student, afraid of death.
Who I am now: A woman who doesn't want to tell you her age, project manager, indifferent. Death leaves me indifferent (cold).
Death leaves me cold.
Death is the end, that's all.

The 25-year-old still lives on somewhere – in the same place as him. A stranger.

'A year went by, and again I had become exactly one year older.' Repeat X times.

Yesterday at 6:45 am
I dream of the dead. Grandpa, my father, Bamse. They are the living dead, for real. Zombie is an unpleasant word, whoever would take it seriously? Still, they are zombies, the dead in my dreams. I embrace them, talk to them, all the while knowing that they're dead, knowing that it's not correct to say that they are alive. The dream is unpleasant, stiff, cold. They can break or fall apart at any time and then a slimy substance will flow out of them. Zombies have no more fibers.

The joy of seeing them, the dead, is reserved, unpleasing. Shouldn't it be pleasant to embrace or stroke the dead in your dreams? It should. But my

embrace is careful, so as not to feel the cold and not to break them. If they break, then the fact of their zombieness can't be denied – that which I secretly know will break through in reality. Who can love a zombie, love them to death? These are dead serious questions, no matter that I'm sleeping. I wake myself up. The fact that they're dead makes waking up easier and dreaming less pleasant. Dreams are sinister parties that always bring bad luck.

I think of Martin Bower and his brother who call their dad: 'Our Father'. Our Father who isn't in heaven, Our Father the crypto-alcoholic, bully, hypochondriac, loved by his students, hated by his sons, chain smoker and in the end, really sick and really dead. No one dreams of him, he was too much of a zombie while he was alive.

Yesterday at 11:44 pm
Aaron Lowery is afraid of repetition, afraid of sameness. He repeats his fear of repetition in the same wording every time I see him. His fear repeats itself. I believe one has to embrace repetition, he says, but I can't. Blessed are those who embrace repetition, brace the blessings of those who repeat. Repeat me, reap me. We drink too much.

He wants to be right – no, he *is* right, he has identified the truth. The truth is that fear of sameness is the right thing. He is so enormously right that he identifies with being right. Being right, that's true identification, being the same, copy after copy. Doesn't repetition consist in hardly noticeable shifts, I say, like a kaleidoscope, a myriad? Repetition is a project, a projection. Repetition, repeat me, reap me. Police man, please me, release me.

18 min. Edited
I repeat you, you repeat me, in the end every human repeats every human. Usurpation. That's what breathing is – u. surp. u. surp. To be honest, my whole life has been a repetition of usurpations. Facts rain down on me and change me and the only thing to be done about that is to change a fact here and there, if that's okay. Changing a fact means the fact will change me back, there's no escaping it.

April 7, 2015
Some people aren't good at learning, I'm not good at working, I said. At that time I didn't understand that order effectuates freedom. I still had to learn how to create order, while showing off, saying I wasn't any good at working. You should never show off with whatever you're no good at. Or whatever you don't have. People who boast about their poorness, poor people who. Poorness doesn't make you rich, but unhappy.

The repetition of the workingman. You think you're trapped in repetition. Trapped, though, is the one who believes in the poorness of freedom – no, the freedom of poorness.

It's like this: You are supposed to conform to society's expectations out of free will. That can be deemed problematic, or you could just do it. Do it goddamn it, act like you have a free will. Then you are free and able to do as you please, but that which made you free – meaninglessness – deprives freedom of its meaning.

I once thought: to be famous at 27, or goddamn it, have a child at 27, welcome a civil life at 27. Being

dead and living on. Then you turn 27 and think nothing. Repetition becomes necessity.

Now
Reveal the secret. Cave beast no cave.

3 hrs
Lights off, spot on. In your head. Then the night dissolves into factors. An exploding sun. Faces and their riddles, forgotten names, tasks, to-do's, toodooloos.

Say I find an envelope with a 100 notes of a 100 euros. What could be a situation in which that happens? A shoot-out, the pursuee loses an envelope from his backpack. No, you'll get shot yourself. By the side of the road, in the grass? A body in the ditch. If you keep it, your life won't be certain. Money laundering, buying real estate. You know you'd bring it to the police. You used to think you wouldn't, but you would. What do rewards do these days? 100×100 euros changes everything. But realities are slow and indescribably detailed.

3 hrs
Every living creature in this world dies alone. Repeat X times. I thought: 'All creatures die alone.' Who cares? Well, 'every' surely is something different from 'all'. Every creature, that's them, one for one. 'All' means: who cares who they are. And they live, apparently, every living creature lives in itself, they are living creatures that die, which is worse than all creatures, dead or alive. In this world – we can skip that, in my opinion, because outside of this world we don't know a thing. This world, our world, the

world of Our Father, but without him. Alright just leave it, so we don't need to argue about aliens, or the dead, or zombies, or gods. It would only impair the discussion.

Whether it's true I don't know of course. What do we know about all creatures, every creature in this world? Sometimes I imagine that scientists will discover that plants have feelings, or to be more precise: feel pain. Some animals can feel pain, we know that much: mammals, and other species with complex nervous systems. Who cares. But what if all living creatures (the dandelions and the apple trees and the blades of grass and broccoli, potatoes, and so on and so on), if all that lives can feel pain, in other words, is in pain? Add up the numbers. Can humanity, can every living creature in this world live, knowing all the pain they inflict on the trees and the plants, on vegetables and flowers? It would increase the amount of pain in the world with the power of a billion-billion-trillion. Wouldn't we collectively impeach ourselves and just call it a day? Or would we think: we all die alone anyway. My zombie called: 'When I died, there was no one around to see it. I died all alone. It's fine.'

3 hrs
I lie in bed, a magnet: the sun pushes me down and up in one go. Or is it dark already and is gravity breathing? The mattress vibrates beneath my body; the vibration lifts me up. But the air above me is heavy and doesn't want me. It's gravity alright, too light and too heavy at the same time. The same goes for my eyelids. You need to keep the lid on, don't squeeze, but ease. There's a pulley on my eyelid, it

starts to move on the vibrations of gravitational forces. Beneath me, glistening listicles.

Now it's the ears that vibrate, but because I want them to. I want to hear. Footsteps in the hallway, one after the other, one in front of the other, step, step, don't stop, it's kitty cat. As long as I'm not dreaming it will be the cat and not a zombie. A living cat vibrated into being by my ears; it walks across the hallway, paw by paw, I hear how she pushes the door open with her head, winds around it into the room, stops, braces herself. Then the hearing stops and I start feeling. Paws on my body, she pushes me down, into the mattress. Steps of paws. The magnet turns and sucks itself onto me. The weight of a living creature, or I don't know, she's dead, the kitty cat. She died alone, but as long as you're not a zombie, you're alive.

5 hrs
Trying very hard not to think of the other ones. Not to think at all. Of course, I still think, but not of the deceased at least. Name all the names of all the friends of your children – no, the children of your friends. Peeta, Teddy, Peeta, Teddy, Dan, no Stan, twice Luke. Name the names of the pets of the children of your friends. Teddy again. Teddy, Teddy, Teddy. Bamse. I follow Bamse's steps on my body, she's trying so hard. Where did Teddy come from? Pets, children, because further back: Bamse. The door closes, the little head, the step of the paw in the hallway, the magnet, the sun. It's correct.

Then I see a someone, who is it? What's he doing here? There are no steps to follow back. It's Aaron, he's drinking and he says: I accept chaos, because

acceptation means neutralization. The joy! Logic breached itself, it means sleep is nigh. I keep calm and look at my subconsciousness. I enjoy the sight of it. There they are, my subconsciousness and me, both existing at the same time, and mutually exclusive too.

The sun dies in the shadow.

2015

NOTES TOWARDS A SPREADSHEET NOVEL

'to be an accountant in the age of spreadsheet program is – well, almost sexy'

We work in rows and columns. The rows are numbered and designate things. The columns have letters and mostly designate amounts. Credit, debit, prices, hours, budgeted and realized, etcetera. However, that's not so interesting. The spreadsheet tells a story, a saga, a bureaucratic epic. We can assemble a morphology of the bureaucratic epic; it would be more simple than the morphology of the fairytale.

Preamble: the word, the numbers

Let's start at the beginning. The word.

> spreadsheet (n.)
> 1965, from spread (n.) + sheet (n.).

The birth of the spreadsheet dates back to 1965, but surely that is not the beginning. We need to go back further. I mean, what is a spread? And what is a sheet? I see before me a broad paper leaf, a folio unfolded, and indeed that is the way it is. The very first spreadsheets were made using paper. Endless paper sheets, white as a ghost and just as thin. Secretaries and office apprentices called 'calculators' drew meticulous graphite lines across the sheets, crawling on the floor with a pencil and ruler, careful not to crease the paper. They mark the numbers in the cells extremely lightly; ready to be erased again at once. The boss sits at his desk and calls out the numbers, all the while rattling

away on his electronic calculating machine. When four hours have passed, or four days for that matter, the magic number appears – a number that has been shuffling along the lines on the paper just as slowly as the calculators themselves – all the way to the end, to the last cell of them all. Now it's time to take out the pens. A green pen when something has to be sold at a good price; a red one when the customer needs to be frightened.

Already back then the spreadsheet was a powerful tool, although the impact of its strike remained limited.

> spreadsheet
> spread·sheet \ 'spred-,shēt \
> Popularity: Bottom 30% of words
> : an accounting program for a computer; *also* : the ledger layout modeled by such a program

It won't take long, just some fifteen years – admittedly, that's eternity in computer history – before the spreadsheet goes digital and transforms into the thing we know now, the thing that all office workers are doomed to learn to use, love and put to work, that which we all need to excel at, as excelling accountants, the thing we hate and that secretly gives us pleasure, which gives us power and the ones above us extreme power: the spreadsheet, the 'accounting program for a computer', better known for its metonymical, eponymous, symbolist name: Excel.

Let's start at the end. Consider the numbers:
 '95% of U.S. firms use spreadsheets for financial reporting.'
 '9 experienced spreadsheet developers each built 3 SSs. Each developer made at least one error.'
 'There is even an emerging theory for why we make

so many errors. Reason (Reason, 1990) has presented the most complete framework for understanding why human beings err.'

'A taxonomy of error types… three types of quantitative errors.'

'They compared spreadsheets errors to multiple poisons, each of which is 100% lethal.'

'Mahalo (Thank you).'

Scripture

Often the first chroniclers of a certain period are also the best. The closer the historian is to the events he tries to describe, the more blinded he will be by these very same events. Blindness is good, just think about what the blind prophets are able to see. The more blinded he is, the less objectively and thus the more truly will the chronicler write history.

Also, the further the events recede into the past, the more the historian is blinded by methodology, objectivity, colleagues. He is blind to everything that doesn't fit the spectacle he wishes to see, which means that he is blind to anything that contradicts the methods used, the objectivity presumed and the colleagues contended, in short, to all the interesting stuff.

The first epic of the spreadsheet was written by its bard Steven Levy. It is called: 'A Spreadsheet Way of Knowledge'. It came out in 1984 and in October 2014 it was rereleased in honor of Spreadsheet Day.

October 17th, 1979 is the day the digital spreadsheet is born. Every year the birthday is celebrated on Spreadsheet Day, you can check the date with your own documents. That day meant Liberation Day for all secretaries, calculators, bookkeepers and accountants, and was the moment when numbers got imprisoned. The

freedom gained turned out to be unmanageable, just as it's supposed to be, it was freedom in the same way that a sea in a storm is freedom, or a desert without water, or a galaxy without stars, where humans – the secretary, the calculator, the bookkeeper and the accountant, joined later on by project managers, controllers, treasurers of boards, of committees, of societies, unions and associations, yes, you might say *everyone* – so, where everyone whirls and swirls, worn-out, run-down and hyped-up, weightless and spinning away from the mother station.

Freedom unto death.

It wasn't like that when Levy wrote his epic. Excel was only to be launched one year later, in September 1985. The early adopters used Apple. Their spreadsheet program was called VisiCalc – a mishap obviously. And while work that used to take days to complete could now be done in three winks, the VisiCalc-ees had to preach, pray, beg to be heard. No one believed the Cassandra's. It is said of one of the more shrewd accountants of those early days that he got 'a rush task, sat down with his micro and his spreadsheet, finished it in an hour or two, and left it on his desk for two days. Then he Fed Ex-ed it to the client and got all sorts of accolades for working overtime.'

Characters

Besides the accountant (shrewd, sly) there are others. None of them works with the spreadsheet primarily, but over the course of the years the spreadsheet has crawled closer (shrewdly, slyly), and then, without anyone really noticing, it has nestled itself into computers, started to appear in printed form on desks, became stapled to the backs of memos and project plans, attached to emails and evaluation forms, an obligatory deliverable, a source of

frustration, damned nemesis, a gift from above. *Not that it was secret. Things like that don't need to be. They creep under the radar by being boring.*

Characteristic of the spreadsheet – its power, possibly – is that it doesn't tolerate persons in its vicinity, just types; flat, formulaic, formulistic figures. Liberation Day for the office employee without hesitation turned into a new confinement. The easy measures of a cell. Of course, it works in your honor and glory, because who wouldn't want to be transparent and decent, upright like a formula? Still, one day that formula will break out of its cell and drunk with freedom it will call fate upon itself. Fate comes, everyone knows that, but what it looks like when it comes, is unknown to all.

That someone will be the last branch on an epic family tree.

A family tree in a few generations.

The administrator
The administrator is great-grandfather to the accountant. He was born in Russia, just before the Crimean war. With administrative fervor he works an office far away from the city. What he does, no one knows. Same goes for all the others in the bureau; it is rife with clerks and pencil pushers who are indistinguishable from one another until they cross the magical line, turn forty and accordingly turn into *characters*. What happens? They break out of their cell. Temporarily, at least.

The girls
They who work. Arms linked they march the streets. The army of the working girls. Precisely on schedule with their brisk legs they leave, uniformly dressed in light trenchcoats. Some walk alone, bent forward, with tight shoulders and

soldierly steps in heavy crinkled Cossack's boots, hands in pockets. Others move in troops, their eyes small from continuous giggling; arm in arm they block the road for passing boys, stopping from time to time to shake a hand, energetically, they want to be firm and manly in everything they do.

There they are, sitting in the offices; the crossfire of the typewriters crackling. The girls jerk the handles to make the lines move as if they're working machine guns. With smooth, superficially attentive serving faces they read over the papers that shoot up swiveling; their mechanical movements become circular.

The bureaucrat
You're being called upon by the state, so you can't really be innocent, you know that much, but still no one will let you in on the details whatsoever, basically you're a witness turning up late at your own crime scene. Five or six men in plain clothes, stooped over heavy desks stained by dripping rainwater, a neon light flashing above their heads like a halo, shroud themselves in the grey shadow of non-speaking, in the far corners of the room darkness is hiding, grown silently over the years, and even the rays of light that manage to peep through the closed shutters immediately dissolve into nothing, as if they're being gulped up by the damp air that rises from below. Chop chop, back to your cell! In the little room you're down on your knees, fumbling around with your bare arms, fidgeting around, looking for something under the small dark brown table, something that will save you from the quicksand of bureaucracy and bring you back to the origin, back to your birth place of mud and gray matter mush, smelling of swamp and rotting, you are being sucked up by a spongy, thick noise, as if you are being swallowed down by a gullet from hell.

Who to file your report to? Where to send the bill?

The guru
Now we're on the threshold of a new time. The guru is the spokesperson of a cult that likes to consider itself a cult, an exclusive cult of the future, a future that holds enough space for everyone. Aren't rows and columns endless? Do cross-references not enable exponential growth? Can we not dissect the workings of the world and identify the different cogs that make the world go round, one for all and all for one; and can we then not place each cog in its own row or column? If you don't believe we can, you're not allowed to join and the future will remain closed for you. If you do believe then you are allowed to step inside. It doesn't cost much to be initiated, the threshold is far from high. Just listen to the guru and learn to think like a spreadsheet. Life will become easier.

The project manager
It's her again. For a brief but glorious moment in time she reigned while calculating, secretaring, marching, but then she disappeared again, pushed out of sight by men as soon as their number was up again after two world wars, written up in marriage registers and so away from the office, until all of a sudden, with the birth of a position that seemed to be invented especially for her, she could be made of use once more. Project manager. A project, one might say, is like a spreadsheet, only bigger. They share the same characteristics, which we can summarize in two words: boring and inscrutable. In other words, befitting her.

The invisible one
He who decides and yet isn't held responsible.

He who thinks in bush structures. Bushes, you know, offer a very pleasant way to think about the world. A memo containing a few pointers? A bush. Your email client that has a subject line and an address line? Bush. Your

accounting application operating a main menu and a sub menu? Bush.

Bush. Bush. Bush.

Motives

Sex
Being an accountant in the age of the spreadsheet program is almost sexy. *Almost*. The problem is, there are so little women around to notice.

This is how it works: you are able to do something others can't. You get something others miss. It brings in a lot of money. You are a front runner. Anyone can see that, even those who live in the age of the spreadsheet without knowing. Knowledge is power. Still, the 'almost' is an abyss you are unable to jump over. You have no idea how to exploit your power, how to substantialize sexiness into sex. Yeah sure, by paying for it, but that was not what the guru had promised.

The dream
There's more. It's as easy as that: 'more'. *What you see is not what you get.* The genius of the spreadsheet lies in its mask of transparency, which hides the more (otherwise it wouldn't be a mask, would it).

Isn't that something: a mask of transparency. You'd almost think that it would be physically impossible, but no, it's possible. In no sense can the spreadsheet be identified with itself, everything refers to something else, every number is based on other numbers, which are multiplied, added up, subtracted or divided. But the most important thing to keep in mind is that all these conveniently ordered rows and columns filled with conveniently disordered references and formulas mean nothing if not for the very last step: the mutation. Mutation offers a glimpse of the 'more'.

The first description of a mutation is found in the scripture: 'Gottheil turned to the keyboard of the IBM-PC on a table beside his desk and booted a spreadsheet. The screen lit up with the familiar grid, and Gottheil's hands arched over the keys as gracefully as the hands of a pianist. He pressed the keys that make the blinking cursor hopscotch across the cells and as he changed an item in one cell, there was a ripple-like movement in the other cells; the spreadsheet program was recalculating. His eyebrows rose as he saw the result. Then he punched in another variable, and another ripple of figures washed across the screen.'

The ripple: that's the more. As in a dream, a dream dreaming of sex.

Spirit animal
Bureaucracy has been described as a cephalopod (a cuttlefish), the spreadsheet in that sense could be a tentacle, or a subspecies. The cephalopod is exotic, living in deep waters and oceans far away, at best we meet him on a plate in a restaurant or figured in a mural in a Greek seaside hotel. And while the molluscan quality makes the cephalopod the ideal spirit animal of bureaucracy, it's not homely enough for the spreadsheet.

In the scripture we read: 'I can't begin to tell you how many hours I spend at this. This is my pet, in a way. Scratching its ears and brushing its code… it's almost an obsession.'
The spreadsheet is a pet. An animal with ears and fur made of code. No cuttlefish but a cuddly bear, or a cat: shrewd, sly.

Weaponry
• The report: The report has been known for centuries, perhaps even millennia. The report is always a means

and never an end in itself, and it should be treated accordingly. It trades in information retrieval and transfer, interpretation of information or embezzlement thereof. The ends don't have to be clear beforehand; sometimes the ends of the report are the discovery of the goal itself.

• The sheet: The sheet is the reincarnation of a report, and finally allows for the connection between reports, which used to be only implicit – through stacking, referencing, stapling – to become fundamental and systematic. Sheets are like branches on a trunk, like the offspring of a god, separable only at risk of death, the death entailed by a mutated gene.

• The formula: The formula is a wordless narrative. It's common knowledge that not everything can be formulated with words. We shouldn't let the sophists bully us, says the guru. Behold, the formula. Simple, transparent, unconnoted, mathematical – the pure language of numbers that doesn't tell but shows.

Take up the formula as a weapon and you'll not only feel the weight it holds, but also its stickiness; despite the weight you cannot hold on to it, it slips through your fingers like oil.

• KPIs: KPIs are like the parts of a mechanical elephant.

• Like the most important character, the most important weapon is invisible. Usually it consists of an abstract combination of words, set in title case. The Plan; The Great Report. As the names gain in specificity, the abstraction level increases. Aggregate Progress Report, Quarter Evaluation Prognosis, Hours Registration Top, Philosophical Reflections on Urine Therapy.

Perspective

Who lends the spreadsheet a voice? No one, because a formula doesn't tell but shows. That's why the point of view will lie outside of the true protagonist, like a montage of CCTV shots that shows something without anyone knowing whether and why it's important. Only when there's a fight and the victim is left for dead do the moving images gain meaning. But then hours, days, months, years will have passed and we will have changed into statues.

One perspective lies with the chair. The chair could also be seen as a weapon, persona or theme. The chair carries the spreadsheet worker. No more crawling on the floor or marching the streets. Everyone knows that the one who remains seated is the one in power. Standing desks are thus a way to subtract power from the office clerk. Who could perform a mutation while standing up? As one of the poets has said, the chair 'is like a vast vortex, or an enormous magnetic field, into which people of all shapes and sizes are sucked'.

The chair is just the first step upwards in a life that moves upwards, that requires climbing upwards, with only one goal in mind, a goal that's hidden somewhere high above you. Always climbing, always upwards, like a snake on the wall. Ask the accountant why he feels like a snake that climbs upwards on the wall and the poet answers: 'Because I feel that I'm being seared in the fire pots of purgatory, and only by climbing upwards do I have a hope of life.' Ask the civil servant what hope is and he answers that there is no hope, that he's just a civil servant and civil servants are a kind of statue. Statues can't move, let alone move upwards, no matter what people claim about what it's able to do, all it can do is look upwards.

The accountant knows that the spreadsheet, with its

grid of rows and columns, is the ladder that will allow him to climb upwards no matter what.

Themes

History has been told. Ancestors have been named. By now we've lived a lifetime along the line, it's not even the beginning of the 21st century anymore, this year of 2016. It has been long since the gurus led us into the brave new world, but they make us believe that it is a world that becomes brave and new again and again and that we need them for that to keep on happening.

Evil
Supposedly, 95% of all companies use Microsoft Excel. 1.2 billion people would have Office installed. The battle against evil is fought within the context of evil. To say the least, a spreadsheet is a 'gray medium'. A seemingly trivial outfit for an office clerk, the power of which nonetheless should not be underestimated. As if hypnotized the clerks follow the orders of their master whom no one recognizes as such. Being gray doesn't make it less evil. It claims to bring peace where there was chaos, but it brings chaos disguised as peace.
 Mutation wearing the mask of transparency.

We've brought in evil without recognizing it – not because it looked like a gift, a most beautiful horse, but because we didn't see it whatsoever. Who could've thought that something as boring and inscrutable as a spreadsheet would offer recourse to evil?
 The power of the spreadsheet lies in magic, and he who excels in Excel is a wizard spreading the totality of the gray shadow. Either you let the magic spell be cast on you or you put on the cloak of wisdom yourself.

Arise from the sleep of ignorance and lift the sword! Combat evil with evil, in the context of evil! Expel the shadow and let in the light! The gray shadows should be chased away, ousted with rays of the most gleaming light. Bring peace where chaos reigned! Peace that slowly sinks in shadows, eyes drowsily closing in a state of soft hypnosis.

The sublime

Why do we like to be lulled to sleep by such masters, who tell us what to do, how to do it and when (but never why)? Why do we let ourselves be carried away on a stream, the stream of data that is being sucked out of us, like the blood from our veins? Well, we do it so we can be a part of history, the master plan of the final masters that are here. We enter the story.

The story has twenty sheets, dozens of columns and hundreds of rows. On average a row contains fifteen numerical cells, of which ten contain a formula. About half of the formulas use the results of formulas in other cells; one in ten refers to another sheet altogether.

Looking through your eyelashes a gray shadow can be seen rising up from the orderly patterns: it's a labyrinth made of perfect rectangles. As soon as you enter it, you see nothing, you just feel: first fear, then admiration, and finally sleep. Welcome to the 21st century sublime, Luna Park of evil, which you've entered without knowing and that has you lost.

2016

THE POST-DIGITAL CONDITION

I.

Google 'staying yourself' and you're corrected on the first page of results: according to the search engine what you really want to know more about is how to stay *true* to yourself.

There she goes, a fugitive, my double, a shadow, slipping in and out of the crowd, on the street, down an alley, in and out of the shops. In the sunlight I catch a quick glimpse of her hair, her coat, her face turned towards the side. I mustn't lose sight of her, I must catch her true image, keep as close to her as possible.

But perhaps she is not running away from something but towards something. Where to? She probably doesn't even know this herself. First pulled this way, then that way, her attention is drawn towards the noises and flashing lights, special offers and signs on sale. People pulling at her sleeve and whispering in her ear, her phone buzzing and singing, the screen lighting up with a merry-go-round of messages. Follow her now, stay close to her!

'When I set out to come here, I mean, here generally, to this town, ten days ago,' writes Dostoevsky in *Demons* through the revolutionary Pyotr Stepanovich, 'I decided, of course, to adopt a role. The best would be no role at all, just one's own person, isn't that so? Nothing is more cunning than one's own person, because no one will believe you.' If only things were so simple. Just to be one's own person without concern about who that person is, about who is adopting a role and who is not and without the need to be known and appreciated by anyone.

Almost two hundred years after *Demons*, it has become doctrine to find, be and stay true to yourself. No one really

knows how this is accomplished, however. After all you are also expected to continually rise above yourself and reinvent yourself, again and again. We live in a performance society wherein you design your identity and play different roles in different contexts. Context collapse looms, as you act a role that doesn't match your public at that particular moment, when for instance a photo of you partying surfaces on your boss's timeline. And if you can't manage to act out the performance meticulously, like a magic trick, it's your own fault, you are obviously incompetent. Being one's own person so that no one will believe it? I would rather adopt the role of someone else, in the hope that someone, anyone, will believe that it is me.

In Sheila Heti's novel *How Should a Person Be?* the main character, Sheila, laments: 'You can admire anyone for being themselves. It's hard not to, when everyone's so good at it.' There's one exception, one person who is not good at being themselves: Sheila herself. Of course, we all think this: as I follow a shadow that vaguely resembles myself, people around me seem to sail through life with envious ease. How do they manage it? How do they stay themselves without any problems, while I have no idea who my own person is?

To answer the question set forth in the title of the novel, Sheila turns to the people around her: friends, boyfriends, artists, career coaches, therapists. She transcribes emails, records conversations, flips through the pages of books and makes an attempt to write. Who she is, how and what she should be, be it hairdresser, queen of blowjobs, playwright, wife or recreational drug user, she does not know.

Adopting a role for yourself, like Pyotr put it, may on reflection be an adequate description of modern life. What is the self, after all? Nobody really knows. Self-help gurus claim it is becoming and manifold and at the same time it exists in its authentic form; it is both dependent and ideally autonomous. You can never completely coincide with the

self, never grasp it completely, but you can at least try to stay close to it. The self is a useful illusion – one talks about it as if it exists, and that's really all one can say about it.

By extension, this applies to the rest of reality too. Reality is reclining out of focus, it hides behind stories, images, interpretations, make-believe and perversion. 'Reality' is only one of the many contexts (and a boring one at that) in a world which is saturated with photos, videos, sounds, music, whispered, shouted and written words, language and signs, links, screens, buttons, interactive installations, acceleration and amnesia. In the post-digital condition it seems the world and reality irreversibly drift apart.

2.
'Post-digital' doesn't mean that the digital era is behind us. The concept heralds a new phase wherein the digital has become self-evident, hardly distinct from the 'non-digital'. The digital turn has been accomplished, there's no way back. You'll just have to put up with it, just like you live with the neutrinos that rage, billions per second, through the material body which is yours.

In the post-digital, reality has also become difficult to recognize, just like the self. At the same time, it can't be avoided either. It seems we are obsessed with reality, but before everything, the (social) media are already there, making an act of it, a story, an anecdote. In a comment on the Dutch poetry blog *ooteoote*, poet Maarten van der Graaff wrote the following reaction in a discussion that arose around one of his poems: 'Even if I resist, the world in which I exist invades my language, even with only a slight cough, and that world, next to so many other and far worse things, can be mundane and exhibitionistic (...) This is no joke to me, nor some trendy influence, it is a phenomenon that drives me to despair sometimes.'

The world will always permeate the language of poets,

but since the rise of the web, something has changed. There used to be a kind of delay in contact, and also it happened only by invitation – through the newspapers, TV, during dinners with friends, in the pub, at school or on the streets. Now that world is constantly available, at your fingertips, ready to be consumed in real time and acting intrusively when left unattended for too long. The world reveals itself through the screen, like a party crasher who immediately starts overbearing the party. And from all these screens, from the traditional to the new, language can be heard. In another comment Van Der Graaff describes a snapshot of that world and how it entered his poem:

> In this case, sentences from a episode of MTV Made invade the intimate scene between two lovers. The trivial words speak to me of a world of desire and tragedy. For example, in the concluding scene of the episode, a boy says to a girl: "I want you to feel free again." Perhaps it is a gesture of kindness but the girl doubts his intentions. She suspects he has a hidden agenda and says: "what a good excuse." These are no trendy phrases to me. The imperative "play it cool" is pretty creepy if you think a bit about its implications. Someone who always wants to play it cool, could look at everything they see in the world and say "what a good excuse".

MTV Made is a reality show – the hybrid genre in which one never really knows what is 'real' or what has been scripted and in which the distinction between the two has become irrelevant. What's more, in the case of *MTV Made*, 'reality' is played out by teenagers (people who by definition are not what they are to become). They are 'made' into something they are not themselves. The Wikipedia-page of the program reads like a poem: 'Selena is made into a

surfer chick. / Richard is made into boyfriend material. / Abby is made into a hip hop dancer. / Christian is supposed to be made into a football player, but refuses to listen to his female coach and quits.' And so on for another 280 lines, one for each episode.

The series are filled with American, semi-articulate people, talking like self-help books, practicing their role in society and reflecting on their emotions with the platitudes that go with that. It doesn't stop there. Their sentences return, translated into Dutch – '*speel het cool*' – in the poem by Van der Graaff, published on a Dutch poetry website and reviewed and discussed by other poets, readers and critics in the comment section. I use them in my essay, which is then translated back again into English, and thus the post-digital world turns round and round: from a TV program, via a poem, to a comment on a blog, to a Wikipedia page and finally on paper and back to the web, then paper again. Sheila Heti would say, semi-articulately: 'We don't know the effects we have on each other, but we have them.'

What a good excuse.

3.
In the highly mediated, post-digital world of today, there is a strong desire for a lost and indisputable reality. An unmovable and formidable reality, which used to be the solid basis for all experience. Karl Ove Knausgård brings this longing to the fore: even though he doesn't seem particularly fond of the internet, he is somewhat an historian of the post-digital condition. In *Some Rain Must Fall*, book 5 of *My Struggle*, he tells of his introduction to the world wide web:

> Something else at Student Radio which I hadn't seen before was the Internet. This was also addictive. Moving from one page to the next, reading Canadian newspapers, looking at traffic reports in Los Angeles or

centrefold models in Playboy, which were so endlessly slow to appear, first the lower part of the picture, which could be anything at all, then it rose gradually, the picture filled the frame like water in a glass, there were the thighs, there, oh, there was … shit, was she wearing panties? … before the breasts, shoulders, neck and face appeared on the computer screen in the empty Student Radio office at midnight. Rachel and me. Toni and me. Susy and me. Hustler, did they have their own website as well? Rilke, had anyone written about his Duino Elegies? Were there any pictures of Tromøya?

Knausgård traces the emergence of his series of six novels, *My Struggle*, back to his dislike for fiction, without really knowing where this dislike came from or what to do about it. For him it had something to do with the fact that the unreal world of the media is ever more present, is gradually becoming the only world we live in. If the whole world is already saturated by fiction, why add more stories to it? Knausgård prefers to show real life, the real life of a real person in an increasingly fake world. So he begins to write about himself – beyond the limited categories of fiction and non-fiction or autobiography and history.

Knausgård work, just like Heti's, has been associated with 'autofiction', the French avant-garde genre from the 70s. In autofiction, a transgression is made between reality and fiction as the writer constantly moves between the two. He may use his own name, date of birth and birthplace, the 'vital data' for a real person, but after that he flowingly crosses autobiographical and fictional boundaries in his narrative. Moving back and forth between the two does, however, imply that the two domains remain intact. Heti and Knausgård take it a step further; in the post-digital the boundaries between the two have become redundant, and in that case moving back and forth has become impossible.

In the sixth and last book of *My Struggle*, Knausgård writes about '*virkelighedshunger*': the longing for something real in a world that is becoming more and more unreal. It is the same term that David Shields uses as title for his manifesto in book form: *Reality Hunger*. Shields argues for a literature that goes beyond the distinction between fiction and non-fiction. Made up of all kinds of quotes and fragments, Shields describes as one of the first the effect of the internet on contemporary literature: a contemporary literature that relates to the existential repercussions of never being offline anymore and which deals with the blurring distinction between private and public, with a world in which connectedness is becoming the driving force of social life. The correspondence between Knausgård's and Shield's reality hunger may be a coincidence or not, I don't know (befitting post-digital times); the original, Norwegian edition of *Book 6* was published in 2011, a year after Shield's manifesto.

Both writers do follow the same line of thought. David Shields relates 'reality hunger' explicitly to the supremacy of the unreal, to fiction and stories that submerge or even wash reality away. 'Living as we perforce do in a manufactured and artificial world, we yearn for the "real", semblances of the real,' he writes. In a world in which reality has dissolved, like a lump of sugar in a cup of coffee, the very nature of reality has changed. According to Shields we need something that is true and spontaneous to life, even if this used to be viewed as subjective and hence unreliable. 'We want to pose something non-fictional against all the fabrication – autobiographical frissons or framed or filmed or caught moments that, in their seeming unrehearsedness, possess at least the possibility of breaking through the clutter.' To be able to handle the default of fiction, Shields seems to say, one can only abide by one's own experience.

4.

Even though reality has become swamped or even has been washed away, we are still yearning for it. In truth, it makes reality hunger futile, just like the longing to stay true to yourself when you can never truly be yourself. 'What it's all about,' the Dutch writer Maartje Wortel writes in her short story 'Schrijver II' ('Writer II', from the collection *Er moet iets gebeuren*, which translates to *Something's got to change*): 'I don't want to lie any more.' And: 'I'm not playing a game. On the contrary. I want to show people what they could possibly think if they can think whatever they want.' It's about showing what's underneath all the layers of play and pretense. What becomes visible is not so much a conclusive list of hard facts but moreover, a personally experienced reality or a social reality that can be shared with others.

Facts are no longer that interesting, we seem to have lost our appetite for them. Facts can even be just as fake or unreal as the rest. Knausgård writes at the end of the thousand plus pages of Book 6 of *My Struggle*: 'We can try to peel away reality, layer after layer, without ever actually reaching the center of it. The last layer just covers the most unreal of everything, the biggest fiction of them all: actuality, or ownedness.' In Knausgård's quest for 'real life', the focus is not so much on objective facts as on subjective experience. An experience that doesn't need to be only individual but which can actually point towards something shared or communal, as we'll see later on.

For Shields reality is played out too, and he also counters it with something, a precept: *realness*. Realness in itself expresses a different kind of reality than the factual, namely the reality of subjective experience. He proclaims: 'Reality is something you could question; realness is beyond all doubt.' Whereas reality is only one of many contexts in an assemblage of fictions, realness by definition goes beyond any distinction between the real and unreal. As a kind

of urban form of authenticity (or ownedness, if you will), realness offers truth in a world in which factual reality seems to have become irrelevant. It is an unsystematic and uncontrollable truth, at most (or perhaps in its highest form) an expression of intersubjectivity.

Realness is about something which is more real than the facts, namely ourselves. There seems to be no other alternative but to resort to ourselves as the 'real' world seems increasingly arbitrary and irrational, ruled by crises, unreliable politicians and plastic TV stars who need to be 'made'; a world that cannot be satisfactorily explained by facts and causality, nor by a religious master plan, a world that is pulling at you from all sides and racing through you, like the billions of neutrinos through the body. Our personal experience, our self, if only a shadow, is the only thing keeping the world together. It is the most important, the most reliable, the most real of all.

Realness has become the antidote for the post-digital condition.

5.
The 'post-digital' was coined as a term in the year 2000 by Kim Cascone in an article on electronic music. Now it is used in the visual arts especially; the possible literary meaning of the term is undefined as of yet. Post-digital refers to a phase that begins when new media are no longer new, maintains theorist Florian Cramer: 'the term "post-digital" in its simplest sense describes the messy state of media, arts and design after their digitisation'. Post-digital art works ignore the boundaries between digital and analogue, between online and offline, as best as they can. The revolution is over; all we have is the debris it has left behind.

One of the strategies artists use to express the implications of this revolution, is to give the digital an analogue appearance. For instance, by putting a life-size

Google maps-pin on a roundabout, like the artist Aram Bartholl did, or by printing out thousands of pages from Wikipedia, which happened in an art project by Michael Mandiberg. In the book *Post-digital Print: The Mutation of Publishing Since 1894,* Alessandro Ludovico brought together all kinds of examples in publishing. The artists and writers resort to analogue production methods and materials, such as stencil machines and vinyl, but use them to research the digital. One can see this as a yearning towards the analogue but one which is completely situated in the digital.

What could the post-digital mean in a literary context? Could it be interpreted even as something existential, just as 'the post-digital condition' suggests? I think so. Digitization not only has an impact on media, art and design but also on *people*. After 'digitization', a person finds herself in a 'messy state' in which she needs to find new bearings.

How can people themselves be digitized? Digitization is usually explained as zeros and ones, computers and information technology but the etymological meaning of 'digital' means something else, says Cramer. '"Digital" simply means that something is divided into discrete, countable units – countable using whatever system one chooses, whether zeroes and ones, decimal numbers, tally marks on a scrap of paper, or the fingers (digits) of one's hand – which is where the word "digital" comes from in the first place.' All things that can be split up into countable parts are thus by definition digital. The alphabet is digital because all the letters are a distinct unit, so are the keys of a piano. A fretless violin is not, it is analogue.

A man or a woman is also, presumably, analogue – doesn't the same etymology say that individual derives from 'undivided'? Today this is becoming less and less evident, however. The whole world has been put in a digital framework, in other words, everything has become split up and 'atomized' into pieces, is regarded as countable. This

also applies to people themselves, however analogue they might feel with their fleeting thoughts, mysterious dreams and transient scale of emotions. The desire to measure and quantify, in short to digitize, extends itself to all kinds of humanistic, analogue terrain – all internal activities, mind, body and spirit. Google claims to already know what you are looking for before you have even formulated your question, advertisers comprehend your body and mind better than you understand them yourself, the meaning of happiness can be read from brain activity; and all are based on quantifiable data.

The individual can quite easily be split into ever smaller parts, so as to count, analyze and trade her data. Just like the post-digital artist longs for the analogue, so too does the 'atomized individual' crave for it, not so much as a factual reality but rather as a non-quantifiable state-of-being.

I think the non-quantifiable may relate to what David Shield calls realness. Hunger for a factual reality is perhaps only a symptom of a transition, an illustration of an almost old-fashioned ambition from the time that media could still be 'new'. In the post-digital world, the hunger for factual reality has changed into a new hunger or even nostalgia, for something that is lost to data, a realness that goes beyond all categorization and counting digits.

6.

What could it be then, this realness? Knausgård believes it can be found in art, language, history, domains he calls 'communal'. These domains are not quantifiable, they are heterogeneous. They can only be experienced individually and shared subjectively. In *My Struggle* Knausgård makes an attempt to understand how these kinds of 'fictional' domains can affect reality. Their impact goes beyond the power of a single person and their strong influence thus questions an individual's autonomy. This is precisely why

this impact is more real than the facts of natural science or the chronology of history. As the Thomas-theorem in sociology states: 'If men define situations as real, they are real in their consequences.' Or to quote Sheila Heti again: 'We don't know the effects we have on each other, but we have them.'

The question of how fictions influence our life is obviously not new – let's say it's at least as old as the *Don Quixote*. The capacity to trigger 'real consequences' is of course enormously elaborate and occupies not only fiction as a defined category, but the media in general and even, social contexts and culture. As a so-called autonomous human being, you owe everything to yourself – you can be congratulated (and blamed) for everything that happens in your life – at the same time, all these fictions are continually affecting you without you having the power to do anything about it.

That tension is central to post-digital literature. Another example is the short story 'My Life is a Joke' by Sheila Heti. A woman returns from the after-world to tell the story of her life and death to a public so she can finally rest in peace for eternity. What is her problem? The title already gives it away, her life was a joke:

> Here is the thing: I was a joke, and my life was a joke. The last man I loved – not my high-school boyfriend – told me this during our final fight. I was thirty-four at the time. During the fight, as I was trying to explain my version of things, he shouted, "You are a joke, and your life is a joke!"

It's an intriguing and irritating lecture. What the heck is going on? People say all kinds of stupid things during a fight. For this woman however this exclamation – 'You're a joke' – is a matter of life and death, literally. She elaborates

on the serious consequences the joke has had on her, as it became an epithet of her life:

> When a person slips on a banana peel and dies, then her life is a joke. Slipping on a banana peel is not how I died. When a person walks into a bar with a rabbi, a priest, and a nun, and that is how she dies, then her life is a joke. That is not how I died. When a person is a chicken who crosses the road to get to the other side, and that is how she dies, then her life is a joke. Well, that is how I died – as a chicken crossing the road to get to the other side.

The exclamation that she was a joke and her life was too, may only have been a thoughtless reprimand by an ex-lover, but it has become the mythical essence of her existence. What she is, how she died, the beginning and end of everything. An absurd interpretation that has grown out of proportion. If death is the consequence, if you're not even allowed to die but need to deliver a theatrical apology in order to truly die, what is real or not becomes completely trivial. What could she have done about it? Absolutely nothing, except to give account of her crushing defeat in front of a gathered crowd.

7.

In post-digital art, the artist recaptures new media and brings them back into the offline world. This also applies in literature, with the material of the writer, namely language. The language of MTV that surfaces in the poem of Maarten van der Graaff is but one example. Sheila Heti too echoes the language of popular media. Not only emails have been included in *How Should a Person Be?* (which is not so shocking for a novel these days), her style, which sounds a bit awkward at first, seems to have gone through the social

web. In so doing, the book gives a voice to how, specifically now in this day and age, one 'must be'.

She is, for example, exceptionally good at what sounds like inspirational quotes: 'Catalog what you value, then put a fence around these things. Once you have put a fence around something, you know it is something you value.' Her heart spawns all her feelings and she scatters exclamation marks as if she were an eighteenth century sentimentalist or a keen Facebook user. 'My heart caught on my rib. If only I could figure out what that was – the decision that would benefit everyone – I would do it!'

Knausgård, who fiercely dislikes the social web, expresses his deepest feelings in *Some Rain Must Fall* like so: 'Ooooh. Ooooh. Ooooh.' Knausgård's style has often been described as nonchalant, his imagery as imprecise, his words too grand and indefinite. Just like Heti, he can be extremely sentimental. Seen within a post-digital context however, his style gains maximal expression: it focuses on making connections with people, sharing the things you feel and opening up who you really are, whatever that might mean. 'Everyone was interesting, everyone had something to say that I could listen to and be moved by until I left and they were reclaimed by the darkness.' He continually tries to connect with other people but without much success. 'My plan had been to write. But I couldn't, I was all on my own and lonely to the depths of my soul.' These are pretty monumental words, yes, which he uses without an inkling of irony.

Heti too leaves irony behind:

> For so long I had been looking hard into every person I met, hoping I might discover in them all the thoughts and feelings I hoped life would give me, but hadn't. There are some people who say you have to find such things in yourself, that you cannot count on anyone

to supply even the smallest crumb that your life lacks. Although I knew this might be true, it didn't prevent me from looking anyway. Who cares what people say? What people say has no effect on your heart.

In a roundabout way, Heti is looking for the wisdom of others; how she may learn from it, even though she doesn't really want to listen to them when it comes down to it. The expansive, chatty but always hyperbolically serious and tongue-in-cheek way she writes, reminds one of the language of blogs, the online genre which literature has always adamantly tried to avoid. In an article by Kavita Hayton about literary weblogs from 2009, for example, blogs are viewed as an inferior form of writing, only meant as intermezzo and unfit for paper, hence their online existence. The writers give these blogs titles such as 'throwaway language', they are thoughts that ask the reader to be 'uncritical'. In 2009 these words were not positive, let alone possible unique selling points. 'It is apparent,' Hayton states, 'that the informal, "throwaway" language in the titles of these blogs would not translate well onto a book cover'. Heti's title *How Should a Person Be?* shows how much this has changed.

8.

This 'post-blog' quality, that shows a post-digital venture with the writer's material, also relates to what Knausgård calls the communal. Both Heti and Knausgård maintain the myth that after a long struggle with themselves and the outside world, they quite naturally, even automatically wrote the book we are reading now (in reality, so to speak). Both wanted to write something completely different, a conventional novel or commissioned play, but failed. They struggled with this up to the point of self-hatred and eventually gave up. As happened before on blogs, the

writers share with the reader their experience of how much effort is needed to produce something. In the end, they only succeed in writing when they just sit down and let it happen, once they put their 'adopted role' on hold, decide to let go and let themselves be carried along with the flow of the world. It is only by surrendering to a kind of *écriture automatique* that they are able to come closer to themselves and they are longing to show the reader how this process works.

Maartje Wortel writes in the aforementioned story 'Writer II': 'Marie. She says she would rather I didn't write about her. I exist for real, you can't make that any more beautiful. I don't want to make it more beautiful, I say.' She pleads her lover; can she include her in her work? – 'I would rather you didn't,' she says, but the writer goes ahead and does it anyway. Just like Sheila records and transcribes the talks she has with her friend Margaux in *How Should a Person be?*, even though Margaux doesn't want her to. The voice of somebody else helps them to find out how to write about themselves, about who they are, even though this eludes them, time and time again.

Van der Graaff seems to have let go of principles like these a long time ago. He makes the automatic activity of writing explicit in his poetry volume *Dood werk* by using stylistic techniques like lists and 'clocked poetry'. 'I time the poem to be free,' he notes, even if it is only a question of sitting down, beginning and producing words. The others will enter by themselves. In what seems almost a striking portrait of Knausgård, he writes: '11:30: Somewhere in a poem, / an article, or in a conversation, / I met an exchange student / who during his stay abroad in a country of his own choice / had spoken to no one. / His dry, mineral loneliness touched me / and I thought of all the ambitious, friendly people / who are lonely in a paradise of knowledge, / growth and technology.'

Perhaps everyone is lonely in a paradise of knowledge, growth and technology. In another clocked poem Van der Graaff writes: '1:37: I live in Holland. / I am a secret / that is kept by certain / communities, who are not inclined to share.'

A community who keeps secrets, not inclined to share, must be blasphemy to digitization, to a world in which everything is becoming quantifiable and split into data, regardless of the generation of data we are supposed to make happen ourselves through sharing. The analogue, that which cannot be digitized, is kept secret in the heart of the community, and this secret is the ultimate object of desire for the post-digital condition.

Sheila Heti writes about how the communal can form a positive experience: 'Luck unfurled at the slightest touch. I had a sense of the inevitability of things as they occurred. Every move felt part of a pattern, more intelligent than I was, and I merely had to step into the designated place. I knew this was my greatest duty – this was me fulfilling my role.' It sounds almost like a religious experience. The flipside of this communal pattern is a kind of limitation to one's freedom. It is the paradox of the post-digital condition: you are supposed to be free and autonomous but you cannot escape all the external and uncontrollable influences that come from the world we live in. The community is both desired and feared, we suffer because of it but at the same time, we seek it.

9.
If the communal is the analogue experience we are all looking for, it inherently triggers a contradiction. Language and images surround you in the ugly, trivial, exhibitionistic and messy world that hustles itself into your perception through all kinds of sounds, images, opinions and statements – something you need to resist. At the same time

these shared cultural expressions are the interface between the individual and the collective, generating the communal: jokes, the language of self-help books, popular programs, social media, and also history and poetry. They present an opening towards the communal, are an expression of the desire to find a connection with others, to be absorbed in a shared world. At the same time the communal can also feel constraining, a cultural straightjacket even. Knausgård's hundreds of pages of analysis of a poem by Paul Celan and the autobiography of Hitler in *My Struggle: Book 6* are poignantly illustrative of this ongoing duality.

For Knausgård the heart forms the symbolic interface between the individual and the communal. Just like Heti, the heart beats through his novel, starting with the very first sentence: 'For the heart, life is simple: it beats for as long as it can. Then it stops.' A heart is *somebody's* heart and, at the same time, it is something we all possess. The heart is yours but at the same time, you have no power over it – if it stops, it stops and then everything stops. The heart, Knausgård says, is ultimately both individual and communal at the same time. 'The heart never errs. The heart never ever errs.'

The heart and its countable heartbeats are perhaps our most precious possession, now under siege by digitization. The internet gave unlimited freedom to be who you wanted to be – an illusion we have been bereaved of long ago. We are being digitized to our hearts and who we are is being reduced to 'vital data': name, birthplace, date of birth, and even more datafiable units. To deal with this, I read in the work of these writers, we have to loosen our contrived grip on our own private core, stop resisting so as to be able to move with the flow of the world and swim with the current of the communal. We need to let the world in instead of keeping it out, compensate the digital with the analogue, understood as that which cannot be divided. The individual? Maybe – but

it would have to be an individual who does not believe in staying herself, staying true to herself.

Maarten van der Graaff writes in the article 'Druk op huid' ('Pressure on the Skin', published online just like the other comments quoted): 'The problem is I don't know how to write about the community. (...) I don't want to be creative. I want to disengage from my inner world of struggle by just writing "me, me, me" incessantly. Sometimes I think the epic can be achieved through dissolution and entropy. The Epos as an exercise, a series of movements that doesn't tell the "story of the tribe" but at least, makes it audible as a social sound.'

How might that social sound transmit as? 'Ooooh. Ooooh. Ooooh.'

2016

40: A FICTITIOUS SMARTPHONE ESSAY ON FRIENDSHIP

Reading instruction: This essay was written to be read on a smartphone.

I am a friend to forget about.

I sit in my room and imagine everything that's going on outside of these four walls. The movements of the people on their way – to each other, from each other, on their bikes, walking, calling, 'running a little late'.

I wait.

*

Research shows that on average, one loses two friends with each 'life changing event'.

Things counted as life changing events are: turning fifty, having children or children moving out, losing your job, getting married and/or a divorce, accidents-illnesses-death of a loved one (or yourself, I'd like to add).

You lose so much already and then two friends give up on you too. How many friends one gains after such an event the researchers do not mention.

*

At what point do you call someone a friend? Formulating an answer to that question is like balancing on a cord drawn across an abyss just to prove to the ones who are securing you with a rope tied around their body that you trust them. A balancing act that might be disturbed just like that, by a light breeze. And then you are left alone.

In general the question isn't taken seriously, or, at most, up to the level of a school essay: 'Define friendship.' No one knows the answer, and no one dares to sidestep Aristotle.

A friend is someone whom you want to treat as a friend, that's about all one can say about it. Tautological definitions are a sign that nothing ever really changes and this one indeed sounds like it's coming straight out of Aristotle. 'Virtuous is what a virtuous person would do, given your situation.' A friend is someone whom you treat as a friend.

Still, tautological definitions are in themselves good definitions. They function; they immediately conjure up what that might be,

who that would be. And they can't be reversed. A beneficial situation doesn't turn someone into a virtuous person; someone who is friendly with you isn't by definition a friend.

*

The follow-up question must be: how do you know whether you want to treat someone as a friend? What does the friendly treatment convey? This expediently leads to the issue of the demarcation criterion, as is usually the case with 'What?'-questions.

The demarcation criterion I've used the most – although I must admit that the last time I needed it lies far away in the past, so far away that the corny joke comes back to me: 'the last time I had sex the sax was still hot' – anyway, this particular demarcation criterion was to be employed as follows. Imagine this sex/sax leads to conception, then what do you do? Very rarely have I thought: let it come, we can handle this; more often I thought: let's get rid of it, we'll survive. If panic flew through my chest, I knew well enough. Leave and never look back.

Sex doesn't necessarily lead to friendship. What is friendship's demarcation criterion? I think it's this. Imagine the doorbell rings in the middle of the night and the person who's ringing needs you. What do you do? No –

what do you think? You treat as a friend those who are allowed to ring your doorbell in the middle of the night.

If I try to reverse this scenario, I begin to doubt; whose doorbell would I dare to ring? The demarcation criterion isn't reversible either.

*

What I don't believe in is this: the number 150 that is supposed to be the natural maximum number of friends. This number is – no surprises there – based on ideas about prehistory and hunter-gatherers, and would apparently be applicable without any problem whatsoever to neighborhoods, schools, Facebook feeds, weddings.

How does it help me to know the size of the groups in which our forefathers moved across the steppes? I want to know how I can prevent loneliness from entering right now, entering me through the open window, through my phone, from the depths of my memory, prying from the piles of books and magazines around me.

I've counted them. They amount to forty, rounded up. Of this forty there are five who I am sure would count me, if they counted. Of the other thirty-five there must be ten who would at least consider me.

The rest I consider to be my collection of personal favorites. No one has to know who they are. On good days they are

a bonus, on most days they provide me with the sadness of non-mutual indifference.

I imagine that you get one friend every year and then one friend less every year. When you reach eighty, you die.

*

Slogans for friendship. Here's one, for or against: '*Two powerful men being friends is an inevitability. Two powerful women being friends is a conspiracy.*'

What this slogan writer doesn't understand is that friendships are *always* a conspiracy, whether they are between men or between women. We swear loyalty to each other, with blood and spit and our pinkies hooked. Nothing is more delightful than to be part of a conspiracy. As soon as you're kicked out of the union you'll know why. It will be like sitting in a room with noises drifting in from outside, but only hearing one side of the conversation: 'Running a little late, don't wait for me.'

*

It is said that women talk and men do stuff together. Whether this is true I don't know. I have talked a lot with friends and girlfriends, but rarely without doing something at the same time. Usually drinking beer or eating, but still.

Doing stuff, that means doing something which elongates time. A dinner has a certain duration and when you eat dinner together, you will have spent a part of the day together. Talking also takes time, but if there's nothing to measure the time by except for the words that fall out of your mouths and disappear again immediately, nothing will ever solidify.

*

I've always thought it was strange when grown-ups talk about 'my best friend'. That was a thing in primary school; in some cases it was a tool for negotiating. In secondary school the best friend was elementary for survival. But continuing on with 'best friend' after twenty, twenty-five is sad somehow.

Why? Am I perhaps just jealous because I wanted to be that person, am I disappointed because someone else turns out to be more important than me? Is there actually nothing I want more than for someone to point me out and say: 'that one over there, that's my best friend.'

Or is it because I don't have a 'best friend' anymore myself since I've decided that 'best friend' is a childish, claiming, hurting, morally doubtful hierarchical title? Is it because I'm reminded of my own best friends, that chain of ladymaids, those I never see again, whom I have shed like feathers, or with whom I have fallen out of grace myself without ever knowing why? Or is it truly because the epithet of 'my best friend' echoes the hit parade? The figure of

'the best' automatically casts a shadow behind itself on all the lesser ones, and I think that all people are equal. Except perhaps my oldest friend, I mean the one who has lasted the longest.

*

My phone rings. No, it doesn't ring, a notification lights up is what I mean. Let's talk about *now* for god's sake.

It is said that since Facebook the term 'friend' is subject to inflation. Another completely nonsensical belief based on nothing. Like anyone really thinks that a Facebook-friend is a friend, a friend according to the demarcation criterion, however you define that.

It's hubbub, just like the idea that 150 is the natural maximum to the amount of people that you can tolerate around you. 'Friend' is a word as strong as an oak, with roots going way back down to the middle ages. Just like the word 'like'. It will survive a little thumb, really, those words don't need our protection at all.

Opening a Facebook or Twitter account might be seen as a life changing event, by the way. How many friends do you lose and how many do you gain? More than two, I reckon, plus and minus.

*

More than half my life ago I met Anna. I was one grade ahead of her, but she transferred from another level and stayed back for a year, so she was one year my senior. Older and even more skinny. She rolled her cigarettes (like me) and hated gym class – I had managed to get a leave of absence (something concerning a weak spine), she just wouldn't do what she didn't like.

In spring and in summer – and spring started March 21st, summer ended September 21st, the school was very strict on those things – our classes joined together for gymnastics on the grass field next to the school. The first couple of times we took on the role of referee, dragged around cones, or hung around the sand pit where our classmates did long jumps, taking down the meters and centimeters.

After a couple of weeks we didn't bother anymore and stayed in the school yard during gym hour instead. We rolled our fags, listened to music on our walkmen and talked boys. We dug each other to the point of love. We didn't really care about

the boys. But just like those boys I had a crush on and who still sometimes visit me in my dreams, Anna has become my weak spot for all time.

No, not a weak spot. My strong spot.

*

This is not the story of that friendship. It's the story of all the others.

*

The others. We met in the school yard; even the kids who went to the Christian school visited our school yard from time to time. Not that that happened a lot. This other school was located just about half a kilometer east, but usually that was enough to forget about our mutual existence. Rivalry or something like that had nothing to do with it, we just didn't think about each other.

In primary school it was different. The primary school I went to lay next to the one of the 'caddolics' and during break we stood calling each other names through the holes in the fence. We did that because you were supposed to, it's what we learned from our brothers and sisters. Feeling didn't really have a part in it.

*

The distance of half a kilometer between the two secondary schools was enough to prevent childish stuff like that from happening. 'Ah, yes,' is what we said when one of them turned up in the school yard; we shook hands, exchanged a kiss on the cheek and a cigarette. When they were there it was as if it had never been otherwise. There was immediate friendliness.

The distance halted any further deepening of the friendliness, just as it halted rivalry. Not only in our minds, but in our hearts too, we remained indifferent to each other. The indifference was friendly because we shared something important: time.

Even though we didn't see those kids very often, we knew our lives ran parallel to theirs, that we had something in common – these years in this decade, we were what would turn out to be a generation but for now it mainly meant that they passed their time just like us, in similar classrooms, with similar teachers and similar school books, with similar lunch breaks, hours off, weekends, meanwhile listening to the

same music at the same kind of parties, differing in the details at most, their names sounding familiar, but not enough to generate a face.

*

On the other hand, the school yard belonging to my school, so *my* school yard, provided us, schoolmates, with a direct proximity to each other, and with that the most important condition for friendship to come into being was met. At least, my friendships have functioned best *there*, on those couple of hundred square meters that I shared with a couple of hundred other young ones. That was probably because you didn't have to put a lot of work in it. Each day you arrived at the school yard, parked your bike, and there they were.

It must have been the opposite sensation for those kids who were bullied. My god, there they are, again. Each day I was relieved, again. Sweet Jesus, thank god, there they are.

*

Proximity won't let friendships bloom automatically, just like proximity isn't a guarantee for or against rivalry. The school yard has a bad reputation: as soon as there's a case of gossiping, bullying or group forming, like in a work situation or a neighborhood, you can be dead certain that someone will start to mumble that 'it's just like in the school yard'.

Whatever. I can engage in profound longing for the extended enclosure that the school yard gave us. It was round, it offered itself to your view all at once and had enough space for everyone. Plenty of hiding spots in case of rain. Multiple entries and exits. A panopticon, but with porous walls.

Proximity might not lead to friendship immediately, without a shared space it gets a lot harder to start one and to keep one going.

*

A shared space and a shared time: both are essential, but sometimes you can hardly tell them apart. There was always a tomorrow when we met in the school yard. Time went by without you noticing it and left some kind of residue behind. Layer after layer a ground grew beneath our feet, a shared ground. We walked about on the same ground, and the longer we walked on there, the more obvious it became that the ground was something we shared. From that moment on we were friends, no one would be able to stop it. The school yard, one might say, was duration turned tangible, right beneath our feet.

('Duration means nothing more than long,' someone else mumbles. Yeah sure, and in Dutch 'duur' means expensive, but what use is all that?)

*

I haven't lived in that little town
for quite some time now, with
the one school on the one side
and the other on the other and
the two primary schools in
the middle. Most of my class
mates left too. They still live just
around the corner, basically.
But even though we moved to
the same city, we couldn't take
the ground beneath our feet –
the duration turned tangible
– with us. Every day everyone
fanned out, like so many kids
of a big family; to an office,
to the university campus, to
construction sites, event spaces,
institutions, or to the work-at-
home desk in the back room,
along highways, through train
stations, or on the bike.

At night I did little to nothing. I
waited for the weekend, but even
then not a lot happened.

I wanted to have a local hangout.
Such a hangout would grace
us with the possibility to find
each other without having to go
through too much trouble and
the residue of friendship would
start to come down again. A local
hangout would be like a school
yard for grown-ups.

In TV-shows there's always a fixed location which functions as a school yard. The archetype (Aristotle might have come up with it) is to be found in *Friends*. To be clear: that was absolutely not what I had in mind. That show is younger than I am, we've been friends for far longer than those folk, that's for sure. Phonies.

Besides, our interest was not coffee, but booze.

*

Of course the philosophers regard the philosophical characteristics of friendship as the most important, so they claim that friends should make each other into better persons or must intellectually challenge each other, but if you ask me the most important friendships are all about fun: doing fun things together. Not just talking, but doing stuff that lets you measure time.

Anna and I could talk abracadabra for an hour on end, just phantasy words and sounds. We didn't need real words, we understood each other anyway. Those were elongated nights, I remember them well (warm). That you're allowed after some time to ring a doorbell in the middle of the night in case of emergency is an added asset of such a friendship. Discussing virtues or the validity of arguments is somewhere at the bottom of the list of priorities. Unless you think that's fun.

What we looked for in our local hangout to be, was booze. No doubt there are friends who like to work out together, who talk about the past, go shopping, drink

coffee, make things. All these distinctive friends with all their distinctive ways of having fun.

I've always considered activities like that bollocks. It all starts with booze, with music and sex, because that's the start of everything. Thirteen, fourteen, the first fag, first alcohol, first drunkenness, French kiss, heartbreak. It starts with the first top 10 hit song that's completely yours, so it starts with 'Smells Like Teen Spirit'.

How the school yards function now, I don't know. There are less physical and more mental addictions, I guess, to Snapchat, WhatsApp, Messenger. The intellectual challenges must be enormous.

*

Sure, I have fun discussing virtues and the validity of argumentation. Not when I was still in school, only later. I can make something grandiose out of it and say that I gathered a group of intellectual friends around me, but even the ones that I met through shared intellectual interests became my friends because of something else: booze and music and sex, and thanks to the porous panopticon of a shared time and space.

*

College is not only a continuation of secondary school because you're still learning, it is too because of the continuation of the school yard. It grew and grew around me, until it covered the whole city center. On weekends I would sometimes just randomly walk into town, looking for people I knew. About thirty percent of the times I was lucky and met someone to go to the pub with.

(It would take years and years before everyone had a cell phone; stuff like Twitter or WhatsApp or Tinder were still a long way in the future.)

Four, five years on a couple of square kilometers: nothing could break us up, except, again, the disappearance of those two conditions that make friendship easy or even possible; we could be broken up once space and time were broken up themselves.

*

In TV-shows it goes like this: out of sight, out of mind. There's a space – the living room, the village, the university, the hangout, the office. That's where you meet. In case you don't, no one will notice.

An actor had to quit his part for personal reasons and is written out of the show. The ones who are left behind will forget him soon after his final episode of goodbyes.

In reality it's not that easy. Out of sight, *into* the mind. The abyss of nothing opens itself and soon enough you fill it up with new, less fun people, but the abyss sucks you in, away from everyone else.

Someone disappears from view and what is left is not a shadow, a silhouette, or even some kind of nostalgia, what is left is nothing. A dimensionless nothing, without contours, without footing. In the emptiness mourning is found and mourning makes itself known *in* the mind, as in the heart.

I've often dreamed of disappearing, of dropping myself hundreds of kilometers to the east without telling anyone. It would be like jumping

into the emptiness that my disappearance will create for the others who are left behind. What stops me is myself: I'd still be left with me.

*

The lesson of the TV-shows, which seemed so harsh to me but which actually is full of grace – 'out of sight, out of mind' – has for a long time kept me captive of the enclosed extension where I lived. I didn't dare disappear from there for a longer time, afraid that people might forget about me.

Not that I would ever forget about them, and I *didn't* forget about them, because the lesson of the TV-shows didn't hold. After some time I've come to understand what is really the case. Out of sight, *into* the mind.

My mind.

I think about them, day in day out, but the thoughts fall dead in the emptiness. I cannot imagine that they, *you*, go through life, like this, harnessed by thoughts, of me.

*

Later still, I became friend of the house. The sequence of those words alone is enough for me to warm up inside. I was like a cat that reported at the back door, knowing there would always be a tray of milk waiting. I called or got a message: 'What you think, dinner?' and five minutes later I was at their door. I was the friend of them in that house, the reverse was not necessary; my own house was reclusive and would only harbor myself.

What happens to the friend of the house when someone moves? This is not a theoretical question, but an existential problem. The movers pack up their lives and continue into their future elsewhere. The friend of the house has nothing to pack.

I saw two options. Either you move along or you stay behind. I helped them pack and when everything was stuffed in boxes, I un-house-friended myself.

I couldn't bring the floor of that house wherever I went, like the school yard beneath my feet. It wasn't my house.

*

Since the internet time and space have changed. Everything is close, so nothing is close. Everything moves fast, so nothing lasts. More and more of life takes place in *non-lieux* – places that aren't real places, places without history, places that can't be pointed out on a map, which lack in identity and for ever hold you in transit, a commuter or transferring passenger.

Social media are non-lieux like that and that's the reason why the cement holding connections between people together, holding friends together, would be crumbling. 'Social media' can't be pointed out, can't be traversed, there's no landscape to longingly watch rushing by as you're on your way *there*.

It takes no time to get there and that shouldn't be understood in a positive way, no, it rather signifies how time collapses, which makes all meaning disappear with a hush. Proximity means nothing anymore. And when proximity means nothing anymore, because everyone is always close, then time itself will become

weightless, meaningless, because we never spend any time with anyone anymore. Who knows you your whole life? We rush from one friendship to the next with the same ease as we switch from one job to the next.

That's what I read, sort of.

*

My smartphone is in my hand. It is a space shared with dozens of friends, or whatever you want to call them. It is a school yard, panopticon, fence, hangout, campus, city center, house.

A kitchen table.

The professors pronounce their doom for us, sitting at the kitchen table. Camera on.

We've lost our ability to talk, we don't know each other anymore, man has turned into an animal, while he was so productively working on his own civilization (ha ha). No one is able to keep his attention on a conversation for more than a minute anymore, is what they say. The smartphone is guilty, they say. The smartphone drives a wedge in the friendly treatment, in the *truly* friendly treatment, the treatment of true friends, not the phony connections that dress up in fancy (or ugly) words as old as the middle ages. The smartphone is smart to yield so much money, otherwise it would have been banned already a long time ago.

I try to remember conversations I supposedly had before and now miss out on. I had the school

yard, the city center, for a short while I even had a local hangout, and the friend-of-the-house-house. There was talking and eating, drinking, dancing and kissing. There were jokes being made: word jokes, bad jokes, inside jokes. What conversations were left behind there, which got lost?

I can't remember and I don't have to. It is a well-known fact that the conversation we are mourning over is the conversation at the kitchen table, where everyone tells how their day went, one by one. A stringent, although not necessarily wide-spread norm, the holy norm of the higher middle class, a WASP-like utopia born in the nuclear family, one that I know of only through American TV-shows.

*

There's no way that Facebook or Twitter or Snapchat are non-identifiable spaces, non-lieux, I will have nothing of it. Don't they have an address that everyone knows by heart, a location on your home screen where you find your way without having to look? Just like we do with physical places that we frequent more often, we start to recognize the surroundings, even if it takes some time to find our way. Sometimes the trusted surroundings are broken up to renovate parts of them and then people are enraged.

Etcetera.

Moreover, they are places where we spend a lot of time. Hours and hours each day, week, month, year. Not only do we share the space, those recognizable, designated, shared places – all the people hanging out there are in our proximity and the residue this shared time leaves is just as real as the residue beneath our feet, coming down on the school yard.

*

Now it goes like this: even if you move out or take off, everything will stay together right there on your phone. No one ever needs to know that you're gone, 'cause you're never *really* gone. If you break yourself lose from the enclosed extension of the school yard that doesn't necessarily mean that you write yourself out of the minds. The minds of your friends are all there, always, just like it was with the porously-walled panopticon that was the school yard. Even if you want to, you cannot write yourself out of minds.

How can I forget them when they turn up again every day, here or there, wherever, online, on my phone, on my laptop, during work, on the train, at home, in bed. My phone has become nothing less than the ground that I walk on.

*

Idea: a plug-in or app called 'Ranking Your Friends', which based on your social networks puts all your friends in order, the order of importance, status, seniority, whatever you wish.

Undoubtedly such a thing exists already. I once saw a Facebook app that visualized the mutual relationships of all your connections and, oh, how great it felt when it turned out that for one of my friends (10) I was in the center of everything.

It exists, no matter what. The algorithmic ordering of the feed as you see it when you're logged in puts your friends in order all the time. That's nothing more than the result of the game 'Ranking Your Friends', a game that has everyone hooked and which we keep playing over and over. Who do you see, who don't you see? Every action is a move in the game, whether you want to play or not. *The algorithm don't lie*.

In this way, the most successful friends turn into the least forgettable ones. Although, when you're a nobody in real life – someone whom no one will think of by themselves – then at

least you can keep the memory of yourself alive online. They won't be able to ignore you, because you keep turning up at the top of their feed all the time.

 *

I've heard say that 'there is status updates, but no friendship updates'. I didn't immediately understand whether it referred to status updates put on Facebook or updates in your actual status – your salary and prestige and everything that tags along: the social circles you move in, jokes you make, what you eat, where you go out – that leave your friends hanging. The friends don't update along but are left behind. Update into obsolescence. 'Sorry, drinks are calling.'

Maybe there's no difference. If a status is updated 'in real life', you can see it doing the same on the social networks: the meter starts running, first a few are added, then handfuls, dozens, hundreds at once. In this violence of the masses the old friendships are rendered invisible, they will always succumb to those with greater status.

This other sort of status update can just as well be regarded as a friend update. People need to be tagged in pictures, a little box circumscribing their faces. On Twitter: the reply, the favorite, the retweet. Everyone's

promoted. You, you, and you!
The less often you are invited to
join, the faster you run behind
in the game of rankings, without
mercy you float downwards, to
that unholy place that no-one
ever reaches in their scrollings,
or even further, into the
bottomless pit from where no
update is ever called up to parade
on the feeds of the network.
You're parading alright, but only
in front of the mirror and behind
the mirror there is no-one left.

Worst of all is demotion. You've
been hidden, muted, ignored,
given the silent treatment, like
could happen in the school
yard. Unlike was the case there,
online there's no one to notice.
Demotion is invisible. It makes
the humiliation a lonely thing
(yes, that is possible), solely those
who are not-updated-anymore
feel that they're left behind by
the happy crew. Only the bots
call for them still.

*

I recount my friends: on Facebook 489, on Twitter 1465, on Instagram 74. The magical line of 2000 (well over 10x150) has been crossed. Although those last two categories technically aren't friends, but followers. In real life it's still 40. 5+10+25.

I try to unthink the numbers and only to picture the faces, the color of the hair and eyes, the names of the children and of the pets that I looked after, but before I know it I've counted to 25, because that's how many children they have made, and 10, the pets, and 5, the ones who share their name with one of the other children or pets.

I'm just not able to demetricate myself.

*

I'm digressing. The kitchen table, back to the kitchen table. Camera's on.

The kitchen table of the nuclear family is the unity of friendliness, that's how it goes nowadays. Everyone is supposed to be friendish, your mother and father to begin with. If you're not my friend, you're my enemy, in between there's nothing. Not at home, not anywhere. It's not necessary to have a laughing fit, surely, but if you can't handle a joke, if you don't have a system of idiomatic jokes at your disposal, if goddamnit you don't understand my jokes, then remove yourself from my kitchen table.

*

Those people who call you by your first name all the time. Those people, Anna. Don't miss out, Josh. Last chance, John. It's the first name treatment, the great equalizer. Everywhere everyone addresses you in the same way – as long-awaited, as old acquaintance, as way back when, as friend. Hi friend, hi Tom and Dick and Anna too.

They want to sell you stuff, like I don't get that! Hi marketer! Hi ad man, hi communications worker, get lost, you commicaterslaver!

When I've been trolling around, lazily filling out forms, the algorithm speaks back to me: hi M, hi X, hi what de fuck. Like being John Malkovich in the movie *Being John Malkovich* there's no escaping your own name. Malkovich, Malkovich, Malkovich. (But I already knew that: even if you disappear towards the east, you'll still be chained to yourself.)

No one believes companies to really be your friend. The reverse might be true: we count companies to our friends because they're always there for us, always have something

waiting for us, never disappoint us and are always ready to please us. You're always allowed to visit their website in the middle of the night. Friends could take that as an example. Can't they treat me a bit more like a product? Haven't I deserved that?

*

By the way, don't expect this familiarity to be heartfelt, the first name treatment is automated, as we all know. So please, just automate your own smile as well if it doesn't come naturally, and your good-spirited greeting too. And in case you don't feel like it, don't be surprised if you die alone, zero (0) friends, found rotting and foul-smelling in your dirty apartment after a week or two.

Isn't that how friendship is threatened, rather than by an inflation in words? It turns into a product that is subject to the laws of demand and supply, a product that companies can provide better, faster, more accurately and cheaper than people themselves.

*

Someone is being loud in the street. 'I gave my students an assignment. They have to write about a dilemma that's bothering them, now, in this very moment. You know, confrontation, collision, it's either/or is what I say to them; you have to make a choice, it is your responsibility, DOING NOTHING IS A CHOICE IN ITSELF, and the result will be tragic, I don't forget to mention that, it'll always be an unhappy end in some way or another, a dilemma means needing to sacrifice something or someone, perhaps yourself, and that's why it makes you feel bad and won't leave you alone, you're being tossed back and forth between conflicting interests, desires, fears, but you must, you MUST, you MUST DO something. And always there are a few who write about their hesitations in ending a friendship.'

'Remarkable,' the other says.

*

I have moved again, way more than half a kilometer east, but not *way* more. I have pulled myself out of the enclosed extension of the city center and landed in a desert made of concrete and steel, like a giant has picked me up from the rumble below with its thumb and finger and has dropped the figurine a bit further ahead. I myself was the giant, of course, I was giant and figurine all at once. From high on up in the sky, bungling by the back of my coat, in between a thumb and finger as big as myself, I saw them, my friends, distancing themselves from me, or I from them. The house I was a friend of, the local hangout and far out back, the school yard.

And suddenly I saw it! They where standing at the school yard, not still, but *again*, not the same one, but another. The school belonged to their kids! I had nothing to find there, moreover, if I would be hanging out there each day surely I would get arrested on account of suspicious behavior.

*

I don't think about my friends from primary school a lot, the girlfriends whom I haven't seen for about twenty years. I can wax very sentimental over them. I still feel as if I'm connected to them through a steel cable. We never talk, at most we like each other's new profile pic.

I see that one of them has seven children by now, not including two foster kids. Not because she's religious, but rather, I presume, a hippie. The children have strange names, the household seems medieval.

I see that an other is still together with her high school sweetheart, the boy who was there already twenty years ago, he is a man now. I see that she is pregnant again, sixteen or seventeen years after the first one, but fathered again by that same boy, man.

I see that the third still is a horse-loving girl, a horse-loving woman I should say, but no matter how much I try to close read her updates and pictures, I can't find out whether she's in a relationship, likes men or women, if besides a dog she has children, or maybe, maybe, maybe.

Should one of these beautiful women show up on my doorstep, broke, doing heroin, chased, wounded, or whatever might be the case, I would pull them in by their arm, stick my head out of the door, look left and right, then rapidly close the door, turn the key and say: 'Tell me.'

*

The first time I heard gossiping I must have been around seven years old. I was sitting in the municipal pool with two of my class mates. One said: 'Kelly's nails are so ugly, did you see?' I was stupefied, I never could have thought you could do something like that with language. (Of course I didn't think that, but I can't describe it another way.) Saying something about someone who wasn't there, and not just something like 'I played with Kelly' or 'Kelly's coming over' or 'Tomorrow's Kelly's birthday' or – and this would've been close, but still factual – 'Kelly still believes in Santa Claus', no, not a statement that informs you of something, but a remark like a poke in your ribs, a remark that sets things moving.

Moving within me, because now I had to answer and not just like that, not just like 'yeah I know' or 'you got a present?' or even 'ha ha, I don't!', no, something flushed through those words, something that I might as well call morality. Whatever I'd say, it would establish an alliance: for or against Kelly. And with that: for or against the gossiper.

So I said nothing, but listened
to my other class mate who
answered: 'Yeah, gross, her nails
are so ugly.'

*

Josh was my best friend. Evidently I was secretly in love with him. I didn't dare tell him because my greatest fear was to get turned down. Would it have been different if there was texting, Facebook, WhatsApp? I think so. It's so much easier to say what you think in 160 characters that might have been sent to the wrong person 'by accident'.

At times my crush on Josh passed – quite often it did actually, because as a teenager I was in love with many people. I kept dreaming about him until years later, long after we didn't meet up anymore. I dreamt everything turned out right.

Then I ran into him. I was well on my way to forget him, so when I saw him I said, as if it hadn't taken me half a dozen years to get there: 'I used to be so much in love with you, I was convinced you were the love of my life.' He said: 'Same here. Me too.'

Here's a slogan for friendship for you: '*A woman and a men being lovers is a friendship-bomb.*'

I let the bomb explode in his face.

*

In the end friendship isn't a product, it's destruction. A self-igniting friendship bomb. The crack in the seamless, happy, content, familiar, is where true friendship reveals itself, but then boom! it goes up in the air.

I read about the terror of presence and think of the corny social network Hyves, where everything was covered in the vaseline filter of innocence: Ich bin dabei!

I'm absent. My chat function is turned off by default. My response time lies well over five seconds. I read everything, but the degree of my interactivity is unpredictable. I won't let myself be pushed about.

Now I hardly get any messages at all. Sometimes I take a tour of the networks, leaving a trace of hearts and smileys, so as to return to myself the glow of presence. It's like I'm trying to make an energy saving bulb light up using a bike, I can see a shimmer of light in the distance, but my legs always get tired first.

*

My phone sends me a
notification: '*Wer am meisten liebt,
ist der Unterlegene und muss leiden.*'

Translate.

 *

2017

SUBLIMINALITATIONS

Bruno Schulz to Tadeusz Breza: 'Dear Sir, I need a companion. I need the closeness of a kindred spirit. I want some affirmation of the inner world whose existence I postulate. To cling to it by sheer faith alone, to lug it along with me in spite of everything, is a toil and torment of Atlas. Sometimes it seems to me, even with all the strain of heaving, that I have nothing on my shoulders. I'd like to drop that load onto someone else's shoulders, straighten up my neck and look at what I have been carrying.'

Hey you, it's me. I want… to let… you know…

I don't really want to talk, nonetheless I'll try to speak to you, because it'll be a way to transubstantiate you through the dictaphone function of my iPhone. There's no one on the other end, I know. I'm just creating a feedback loop, out of my mouth and into the phone and from the phone back into my own ear. And another simultaneous loop – now that the light's changing from high noon to the afternoon, soon to be dusk – from the reflection of my face in the screen, which comes back to me, moves through my eyes into my inner eye and back out again to the eyes on the screen. It starts here with me and moves on to wherever you are, which is simply in my imagination, of course, and then back again to me.

Sure, you live somewhere, I know where your house lives as we used to say, or, at least, kind of, give or take a couple hundred meters. But the you I'm talking to is the one who lives inside my head and occasionally stretches out into my whole body, making my fingers tingle, weakening my knees and filling up my lungs with heavy, delicious floods of air.

And yet you don't really live inside my head, that one restricted place, you don't even live inside your own house, that place that is firmly grounded in a spot that I could approximately point out. In actuality you are everywhere, following me around like a ghost. A friendly ghost, a complimentary spirit.

As you know, it started with a compliment. You gave me a compliment and that started it all. The compliment came down on me like a meteorite, a gentle and soft meteorite, whose impact I didn't immediately feel. It was like the meteorite had followed me around already for some time, with its bright, almost transparent tail, letting me get accustomed to its being there, to the swoosh and the stardust, and then to land ever so softly and gently in front of me, not on my head or anything like that, rather just besides my toes or in my side pocket. From there it spewed up its gravel and stones, defying gravity like a fountain of emeralds, it sprouted up higher and higher and then came down again, out of my sight but *there*, like an old-fashioned parasol, the ones that look like a dome of white lace that filters the sunlight, radiating a soft hue.

Is that silly? It sounds silly. Well, it is what it is. A well-positioned compliment: that's enough to have a meteorite land at your feet or in your side pocket. Who wouldn't be interested in the stone in their pocket that came from outside the orbit, who wouldn't caress it, go over it again and again, and who wouldn't think that touching it with the fingertips isn't enough, that they want to see it, look at it, know it, what kind of rock it is, what kind of color, whether it's even or speckled or glimmering. Who wouldn't take it out of their pocket?

I mean, when does one gain an interest in someone, or in whom? I for one gain such interest in a person, a someone, that gives a display of interest in me. And that's what you did: compliment me in a way unknown; a wholeheartedly interested way. I didn't know how to react. You saw that (since you were interested, I suppose). You said: 'Don't belittle yourself.' So that's what I tried to do: not to belittle myself. Always happy to please. I started talking about myself complimentarily, me, me, me, didn't stop, and the result is that I know next to nothing about you except for a few superficial data points like where your house lives, give or take a couple hundred meters. Another result seems to be that you have no problem whatsoever closing your eyes on me, turning interest into disinterest, and then evaporating, fading out, retreating into your unknown self.

Please just listen to me, like you did. Still do.

Calm down.

Whereas it started with a compliment, it quickly turned into an architecture. I mentioned the dome. A dome that flexibly follows me around, moves with me wherever I go, and keeps me safeguarded right in the middle of its structure, under its crown so to say. From this crown a bouquet of cameras seems to sprout, their heads down, peeking about like just so many flowers. I can't really see them but feel assured that they're there. Scopaesthesia, it's apparently called, 'the psychic staring effect'. This is how it works: when I get up in the morning, I get up for the camera, which basically means I get up for him.

The cameras have always been there, dangling in a corner under the ceiling, registering everything I do. Everyone's always so focused on the cameras and I understand why:

they're like cloaked strangers, masked, harnessed and armed. But in reality, what matters is not the camera but the fact that someone's watching the thing that the camera records. There's someone with an interest in those moving images, why else would the cameras be there?

I know, it won't be long before the camera itself is both the one recording and the one watching, it will be not only the cameraman but also the editor of the movie and the director of its purport. From then on, the mask and the harness will not be like that of a policeman or a detective from a pulp flick, but that of an Orc or a medieval knight fighting on the side of Satan. That's when one should start to get really worried. For now, the camera is just the mediator between me and him, the one who is watching. Surely he's watching, you are.

▶

I look in the mirror, I brush my hair, I get dressed. There's nothing sexual about it, nothing like churning the bum or squeezing the boobs, it's not about me getting dolled up for this person. Plain and simple, it just matters that someone is watching while I go about my morning routine. That, for the one who's watching me do my daily routine, I'm quite someone, a person to cherish, maybe even to admire. To consider beautiful, to love.

This is not new. I was born a scopaesthesiac (you try to pronounce that). As a child I wanted to become an actress, since I felt I already was one. Always practicing, rehearsing as you're supposed to do when you want to be good at something, and especially as an actress: repeating the words, the gestures, the looks over and over again until you've nailed them. A repetitive rehearsal, a repetition repeating itself day in, day out.

We all know that repetition is so very important when one wants to excel, but we tend to forget that repetition also signals affirmation. It's that easy: by repeating something, you affirm it, the existence of it, the importance of it. For example, the importance of a gesture.

The camera ensures a view of the self from the outside, which is the impossible view and the affirming view. Do you see yourself from the inside or the outside? When you dream, do you dream yourself up from a third person perspective or do you roam about looking through your own eyes, locked in your body as usual? It's a false dichotomy, probably. Of course, when I dream, I'm as locked in my own body as always, even when I look at myself from a distance. It's all there at the same time: the bodily feel and the detached look.

▶

Another feedback loop: this one runs from me to the third eye (oh, the third eye) that permits the impossible yet so important view of myself from the outside, thus affirming my very existence, then floats back into myself again, applying the third-eye-look on him. It's like turning the tables after rolling around in the life-affirming gaze for a while, you try to see the camera so you can eventually take over the camera's position and see what it sees. And since the camera really is him, it is him you are looking at now, and you're not just you looking at him anymore (I mean, me looking at you), but through him you're looking at yourself, and the feedback loop starts all over again.

A very concrete practice: the inner eye turns outer eye and feeds back again into your inner eye. It reads in double (quadruple) vision your own Twitter-feed like you were someone else (him, obviously). It scrolls through your

own Facebook photos as if you were this other person. It is surveillance of the self as much as it is a crush on the self.

It's quite hard to put a finger on who's watching who and for whom and why. What's the affirmation you're looking for? What's the import? Well, what matters is that there's affirmative action going on. Even if it's just by looking at yourself through his eyes and then looking at him with your own eyes, et cetera, even if you're an anonymous camera, masked, harnessed and armed, an all-seeing eye without so much as an eye-socket to give the ball leverage. You and I, we are a certain somebody (in plural), and we're watching from eye to eye, speaking from mouth to ear, it's an action that propels love, love and, if you say so, lust, that same old lust that's always been the bottom line, because lust equals affirmation.

▶

In the background music is playing. A soundtrack of earworms. The earworm, that repetitive form, is the soundtrack of the dome. You know, the song that's stuck in your mind – and I don't mean the latest obnoxious pop star thing or the stupid top 10 hits that blast out of every store you go to. No, this earworm is *your* song and you want to know everything there is to know about it. The words, the modulations, the change of chords; you need to know when exactly to turn your feet while you're humming about half-dancing through the room. It's a song that unleashes an energy in you that might be called wild, although the song is not necessarily wild in itself. But it has to be heard again and again so as to feel that energy again and again.

Somehow, the energy has something to do with he who is watching. The song is sung for him, it offers a direct entry into affirmation, it's an easy high. Substance abuse,

you could call it. Again and again and again, especially while getting up out of bed and performing the morning routine – everything starts with a morning routine – the song accompanies you; it is the first thing you hear after the alarm, the first thing you say, sing, to start the day. The song says it all, even if it's just like screams on a scale (those are the best).

The daydream is like an earworm for sore eyes. One might say that's what I'm doing (loving): daydreaming. Daydreaming under the eye of the camera, or rather, daydreaming up the recordings the camera makes, probably even dreaming up the camera itself. You know, daydreams too are a repetition – of something that has happened in the past or something wished for in the future. Like a gif image it keeps replaying itself, it shifts and shapes.

In the daydream, just like in a gif, the loop of images that keeps replaying before your eyes proves to be so fulfilling that you just keep watching. I've heard it say that a gif is of an open and patient nature, since it has no end point but just keeps moving on. The best gifs are the ones that do not wish to be sensational. They focus on small gestures – small, fulfilling gestures of bodies, which have you lingering, that endure being watched steadily, patiently. These gifs lend dignity to movements. You've never watched quite enough, you've never grasped them fully; they always seem to contain something new. It is precisely the small movements that can lift the gif right out of banality instead of plunging it down into banality.

It's also said, and I agree, that the gif doesn't actually show the same thing over and over again but rather offers an opportunity to see something new with each loop you watch.

It might be the same action playing out, but the repetition of the same allows for a discovery of something more. Yes that's it: it doesn't offer something *new* but something *more*. Like when you stroll through a museum and instead of granting each work just a couple seconds' glance you sit down and give yourself and the work the chance for more by looking at it over and over again, seeing more of the same and new instances of the same. The gif, moving as it is, all the while catching and fulfilling needy attention spans, has that exact complicity built in.

The eye, the camera, makes you move in repetitive ways. Someone's watching and that someone wants to watch. So you give him something more to watch. It's a very nuanced movement you make, filled with meaning and significance that gets hinted at but isn't very clearly articulated in itself, even if it just resides at the surface.

Nothing's to be found beneath the surface.

You act like you *are* a gif – not a violent, bloody gif but a gif that subtly shows repetition in movement and makes the onlooker think: 'I didn't see it all just yet, I need to watch it again.' A simple show of both repetition and affirmation (which are one and the same, of course), a mode of practice through repetition, a practice that gets affirmation over and done with all at once.

The architecture of the dome is characterized by repetition. It makes one move in repetition. It ensures that there's always someone there with me looking, not leaving me to myself. It gives me a feeling of security, especially since that someone isn't an almighty, all-seeing god, judging and

damning and making us stick to the rules. No, that's not the case anymore, this is someone who looks at you (me) because he's interested. It makes me feel warm inside, very warm indeed, pleasant and affirmative, affirmed.

At moments I forget about the dome being there and that doesn't matter, because forgetting it means I don't need it at the moment. Then it returns again with its impact of a meteorite, a shower of falling stars. That's when you turn up, *you*, with a face and a body (yours), an eye that travels the heavens like a drone-dome. You, who might be anyone but at the same time can't be anyone else than who you are now.

(It sounds like love, maybe it is love.)

The meteorite hits right there at my feet, smashes a hole in the ground, sends the debris right up into the air, hits me in the face until it starts falling down again and lands in a big circle around me, forming the perfect dome of stardust all around me. Everything I do from now on I do for you.

Of course, you could call it the architecture of the panopticon – that metaphor that has turned out to be so trustworthy, dusted off for use in our times. Not anymore depicting a prison – although the panopticon-built prisons still exist – not so much a concrete object made out of stone and mortar that confines criminals or other unwanted and unneeded persons, subjecting them through architecture to the all-seeing, unseen eye of the guards, seen without seeing and therefore seeing themselves. Now the logic of the panopticon is the logic that pervades the camera whether it's dash cams, police cams, CCTV cams or my own cams. Being seen by a guard makes you behave well, and being seen by camera will do just the same. Although there's no

consensus on whether it actually works like that, whether the 'well' in 'behave well' is justified. It sounds plausible and that's enough for most of us. Being seen will change the way you behave, and maybe that's all that can be said about it. Whether it's for better or for worse, for authenticity or *mauvaise foi*, who knows.

The thing with the panopticon of course is that you don't know exactly who's looking; all we can be sure of is that the ones watching are the ones in power. For the rest they remain abstract onlookers. It's precisely because you don't see the eye that you can't really comprehend it or imagine it being there. You behave differently, namely as a reaction to the way that you think is desired, your behavior is behavior informed by being seen. Which implies that how you behave under the eye diverges from the way you would want to behave if you had a choice. Sure, it's for better or for worse, but it's probably always for *mauvaise foi*.

The panopticon is an uneven institution. Everyone is watched over by not-everyone, by a small portion of the population. Nowadays it is said that online everyone watches along, but the panopticon implies that the majority adapts to a minority. In my own personal panopticon, my dome made of stardust, I reside alone and I know exactly who it is that is watching me. Although I can never be sure that he's watching at all. And by the way, no need to think he (that would be you) is unique, because it's not always the same person looking, thankfully not, you're neither god nor God. You're someone who shows up suddenly and offers yourself to me as an eye, without necessarily being aware of it.

▶

In general it may be hard to know who's watching who in the panopticon. Not only in the sense of who resides in the

tower, who's behind the eye; the panopticon may not be good either in making palpable who's on the receiving end, I mean, who's in the cell. And that would be all of us. But as soon as we start talking about all of us, about the mass of us, that is when it stops being palpable. Everyone sits in his or her cell for a different reason, for committing some crime or another, and everyone cultivates their own regrets and dreams up some dream for the future.

My own personal panopticon is what I want to understand. And I also want to know why my being there doesn't just lead to me behaving desirably and so in actuality, undesirably – because, yes, it does. My own personal panopticon also gives me a sense of well-being. It is very simple: all my daily tasks come off much more easily because I sense that there is someone watching along.

▸

Question: The someone who's watching – the onlooker looking at you (me) – is he watching in real time, like the police officers on service, the security guards who look at CCTV footage streamed live so as to be able to take action immediately when something happens, or even just like the procrastinator on YouTube? Is the footage watched here and now, not saved for very long but rather playing out like a parallel stream of the present, dissolving into nothingness immediately? Or are these images being recorded so as to be watched at a later moment by someone else?

So: am I stowed away in the past or propelled into the future? I'm confused, because being live streamed also means to disappear into history right away, never to be found again. Being recorded, at the same time, sounds exactly like the kind of thing that would make you into something meant for the archive, at once a thing from the

past and a projection for the future. Futurology. I would say there is no record keeping in the live-streamed panopticon. Can the guarantee that someone watches along with you, right here right now, someone for whom you're doing all this shit, still be seen as insurance for the future? On the one hand, he's watching now, so it's likely he will keep doing so. His memory of the past provides the context for the times to come. On the other hand, it is rather my own imaginary insurance; the conviction that there's someone watching is nothing more than an insurance contracted with myself (another feedback loop) to ensure that all will be saved, that I'll stay safe and not just disappear into a non-existing past through a continuous stream of now-moments.

This performative insurance or insured performance is like a daydream that dwells on the past with hopes for tomorrow, like all daydreams. In the daydream the past evolves in a certain way – a repetitive and beautiful way. The performance for the camera is like a daydream acted out in reality, in real time.

▶

There's so much talk about the need to be present in the here and now if you want to live life 'fully'. I have my doubts. Can't life also be 'fully' experienced when it's a life lived for someone else, and perhaps especially so? A life lived in the certainty and in the feeling, in the felt certainty, that you're seen and in that sense, that life is lived doubly? Like the daydream: when dreaming a daydream you're awake, you are here and now, lying on the couch or sitting in the train or walking on the street, all the while being elsewhere, too. Such life is filled to the brim; it spills over.

These aren't the fretting, brooding, anxious and panicky thoughts going through your brain I'm talking about,

but beautiful visions of somewhere else where you dwell because it gives you a good feeling, at least for as long as the daydream lasts. You fill yourself up, inhabit yourself to the edges of your body and your mind is focused on the best of all possible worlds. It is meditation without the mindfulness. It is following your thoughts around, your utopian hallucinations, rather than discarding them. The good feeling probably stops the moment you step out of the daydream and find yourself again there on the couch or the train, in the realization that it was nothing more than a daydream. There you are, and you realize that daydreaming isn't really allowed nowadays, at your (my) age, that it is something that keeps you from what's important, from efficiency, from work, from a sense of reality. All those protestant virtues.

The eye, the camera, gives you a way to effectively daydream, to be there and at the same time dwell elsewhere. The elsewhere being with the person who watches you act. You are sharing his position. It's one of the few instances where an inner separation between the self and the one watching the self actually makes you feel not insecure, shameful, poor, but good. Makes me feel good.

▶

Being too focused on the future is said to keep us from living in the present. Because if you're longingly directed at the future, you don't care anymore about how to live now, or how to change your present condition. It's supposedly the same as being too focused on the past; it's the reason why a traumatic experience keeps recurring, working its trauma on you again and again, barring the present from being really present and keeping the door shut on time to flow forward, towards different times. Both of the extra-presential modes tend to ignore that it's the present

that needs a change. Nothing happens, except for the ever returning repetition of the past or the ever repeated vision of a better future, which all make it impossible for the present to bring about something new –.

But does that really tell the whole story? Isn't it so that daydreaming and fantasizing can also be about something else, something that might have happened in the past or is hoped for in the future, but which is something beautiful, something important? By willfully fantasizing and daydreaming about all these beautiful instances they are activated in the present, the act of daydreaming wakes them up in the present and you along with them.

Just quietly sitting there, you stare in the distance and see the person who sees you, watches you. You dream up actions for yourself, while sitting there absolutely motionless. What goes on inside your head? No one knows. That is exceptional: *no one knows*. Not even the one who sees you and affirms your being in your body, now, here, finally, there, you're feeling it again, you're feeling it precisely because you allow yourself to travel back in the past or on to the future. Not even he knows.

Sure, this won't make a revolution. It won't put anything on the line, it won't set the machinery to work. It won't put the repetitive reactivation of the past to a halt, but that's not always necessary anyway. What it can do is deliver well-being – an ugly word, well-being, but anyway, well-being – a well-being like that of a cat that lies on the window sill, dreaming up the here and now.

The daydream is repetitive like a gif. Also, it is sublimation. It creates a parallel world in which you simultaneously live another life. Isn't that a pretty way to ensure immortality?

Sublimation means that the daydream strikes a balance between rationality and emotionality. There you have me: someone who rationalizes their emotions away into a daydream, always away, always repeating. Sublimation is my middle name.

▶

The architecture of the dome instigates certain mechanisms of behavior: daydreaming, repetitive movements, humming the same song over and over. It is all self-contained. It never leaves the feedback loop of me talking to the ghost of you and onwards, backwards to me again. When the loop turns outwards, from the center of the dome to its edges, beyond the position of the camera, other mechanisms appear; tweaks, sweet little playful ways to go about things. Social steganography, the digital variation on Poe's purloined letter. Teenagers who share YouTube videos with covert messages that others, parents or teachers, don't understand. Me sharing book covers and photos of pages, quotes and blurbs (I share them for you, not with you, as much as I would wish to do so). Instead of keeping a secret, the secret is hidden in plain sight, packed up in an update and posted for everyone to see. All in the hope that the other is able to decipher the message. Whether they can, is the uncertainty that comes with cover.

Not everyone understands the post, thank heavens, they're not supposed to! Whether it's a song, a poem, a witticism or a phrase, they don't know that they don't understand, that they miss out on something. It's always also *just* a song, poem, witticism or phrase. It's encryption in public. Sure, this would count as an adaptation of behavior, but in a highly individual way. I like that this sharing has nothing to do with the accumulation of meaningful data about me. Nothing will be done with my highbrow literary references,

let alone with the references whose meaning is hidden for everyone but me and, hopefully, him. You are the only one to understand.

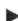

The form that captures such sublimation most significantly now is the subtweet. We need to talk about the subtweet. The subtweet is like a literary manifestation of sublimation on Twitter, where 'literary' is meant as: double-edged, ambiguous, complex. A way of going public with a message that keeps its most important meaning hidden in plain sight. 'Sub' of course means multiple things: something is below the surface of used words or images or references, and it is there that the true meaning of what is being shared is to be found. You say something right before the all-seeing eye, but it's a performance meant for the in-crowd, maybe even just solely for your private eye itself, for him.

When it comes to the subtweet this hidden meaning is mostly negative, because, let's be honest, the subtweet usually hits below the belt, is directed at someone who's on the receiving end, someone who's being set back. Someone is being set back publicly, but you can't blame the one doing it because it all happens under cover. But perhaps the subtweet isn't only directed at someone who's at the receiving end, the one who sent it might be on the receiving end just as well. I may want to be on the receiving end myself, on *his* receiving end. And to make that happen, to make myself available for his receiving end, I put him on my receiving end first. I talk to him without talking to him and pray that he hears what I say. I hope that he who's on the receiving end of my subtweet cracks the code on first sight and knows that the message is for him.

The subtweet as an act of love. *It can happen*.

The subtweet stands in a tradition of secrecy, of stealthy signs and meaningful glances and everything that has to do with seduction and desire, with daydreaming and flirting. It stands in a romantic tradition of one-way traffic that is not so much out to get an answer – although, sure, yes, please – but would give an arm just to be heard and understood, just to reach the intended receiver, all the while hiding in plain sight. Still, you are (I am) protected from the backlash of your (my) own actions.

The subtweet, act of love, is a compliment.

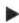

Repetition is the mark of both the lover-at-a-distance and of those who live in exile (both are me, not you). They (I) feed off of a sublimated emotional reliving of a past or hoped-for future that can have a physical manifestation, but mainly exists in the head as a mental phantasy, also known as the daydream. Did I say love-at-a-distance? If it is love, it is love for myself, which indeed travels a long distance, bouncing back and forth in the dome, traveling through other eyes before returning back to me, gazing at myself, pleased and pleasantly.

Constant repetition might look like a drag, but it is what characterizes our concrete lives. Although that's not the point. Repetition is also repetition of that which is given in a human life. You're never a new person with a new life, you always start out or end up in a place that already exists, with something, in other words, that has to be repeated. And at the same time the repetition of a given is also the first step towards something new. Or well, not the first step – there's never a first step – but through repetition minimal shifts can occur and precisely those shifts make change possible. Not every change happens with a leap, sometimes it's rather

a matter of repeating the same movements over and over again, without seeing how they change, minimally.

I don't know if I believe those words. The reflection that occurs through the eye, through the camera, that creates the distance to yourself which allows you to watch yourself as if you were an object – in the end, an impossibility – may seem to be the first step towards something like self-realization, but the step immediately comes to a halt. It's a step, so to speak, that never turns into a leap. Maybe we (I) don't want it to. We start to notice possibilities unfolding themselves in the repeated gestures but we do not take action, since keeping possibilities open is sometimes more beautiful than having to deal with a possibility-come-real. It would in effect lose its quality of the possible, we would have traded in excitement for the boringness of reality.

My personal, sublimated panopticon doesn't cause fear or vertigo but rather excitement, maybe breathlessness, but only as long as it's held out in the realm of the possible. The daydream or the phantasy that shows itself through actions performed for an imaginary camera is a way to hold on to the movement made in the direction of a leap, precisely because the one who's watching is no god, and also not necessarily someone who befits you, but rather someone, just anyone who gives you a feeling of affirmation, who gives a fuck.

I took distance, I glanced in the abyss, and there you have me, breathless and excited. The leap is yet to come (never to come); for now I move ever so little, quietly, and repetitively.

▶

Why does it always have to be me who moves towards liminality? The subtweet is an act of love, yes. But then love

turns ugly, it turns against itself. It becomes conspiracy. I start to suspect that he is doing the same as you. Me. That his tweets are actually subtweets, probably not directed at me but at someone, a cloaked and masked stranger. The compliment turns into conspiracy and conspiracy is always obsessional. So much for sublimation. Ratio and emotion? Not a useful distinction anymore. Now I just have to know everything. Now you need to listen.

The gif can turn against you. All of a sudden while scrolling through your timeline you're confronted with the suicide bomber who blows himself up in Departures, a constant loop shows you more of the same and more and more whether you want it to or not. Well actually no, you don't want it, you don't want to see it, you don't want, even in case of a terrorist. Ten seconds after ten seconds, a shattered body. Gifs are appropriate for funny animals but not for life's end. The gif just doesn't have any sense of respect when it comes to bloody and violent moments, it renders them trivial, banal, extracts all dignity right out of them. It's more like trauma, repeated and repeated over and again.

▶

Parallel worlds turn into parallel rings of hell. I mean, there is an actual, dead serious branch in science that investigates the many worlds hypothesis. The idea is that there is a plurality of worlds, a plurality of universes, but that exist for real. Other universes in which our own universe is copied right down to all the small and minimal – or liminal – differences. The big question, the all important mystery is the following: if there are many different universes that only differ from ours in a very tiny measure, in which we also exist and do our things, live together, kill each other, love each other, are born, die, but just one minute later, or with different clothes on – I don't know exactly how

they picture all this stuff – then the question is, when you think of all these other selves in all these other universes, doing the same thing you do, who *are* you, pretty much, just slightly differently, but in effect you *are* them: do you feel compassion, or do you think: maybe they *did* go ahead and killed themselves already.

Surely there must also be universes that have nothing to do with ours, but no one talks about those.

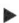

The question that pervades every story starts to pervade this one as well: in the end, does she die? Maybe the question is especially pertinent in the story where you play yourself, the story that is followed by someone every day, someone else from yourself, someone who looks through the eye of the camera. Doesn't the question push itself forward, just like in any other story: does she die? Yeah, sure, everyone dies eventually, but not every protagonist dies in every story. So, this is what you might ask, being the protagonist in your own story: does she die? In this story, does she die? Being watched over, by you? Or by someone else altogether? Is this story supposed to end first so another story can begin, before she will eventually die?

I know of a 'passive longing for death' also known as 'a theoretical interest' in it – you don't really want to die, you definitely won't go through any trouble in order to die, but you can sometimes long for it passively, you might think, oh well, once the time has come, it'll be alright. You won't do a lot to keep death at bay. And meanwhile you hope that all those small movements will activate something. That repetition, the repeating movements, the movements in their repetition that all the while shift again and again ever so minimally, at one point will make you shift ever so

lightly out of life just like that. Like wrinkles that shift into your face and in the end shift you out of life.

You shift out of life like the wrinkles shift their way into your face.

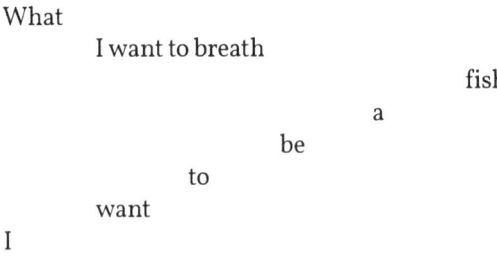

▶

Die Wende, June 21. The dome around me crumbles, sure, a couple of bricks had fallen out already, in the past days I saw here and there that the disintegration had started, but, oh well, you know, well, you (I) just don't believe it. But now it comes crumbling down with a big loud rumble.

The dome is gone. I'll never feel its presence again. My subtweets do not arrive at their supposed destination, and neither do my likes, nor my feedback loops, for that matter, they all fly off into the distance and evaporate. As long as the dome is still there you know for certain that the message has arrived even *before* you sent it, it got read the moment you wrote it. The subtweet arrives before you even hit the button. Then at a certain moment it becomes clear: no, nothing arrives, nothing is received. And it's not because of a faulty connection or an unexpected downtime – no, nothing arrives anymore because the other has closed his eyes and keeps the eyes closed. He has closed his eyes, so now I find myself alone and unprotected in a big empty, domeless space.

▶

It can happen. All my scopaesthesiac daydreams could have happened. The other option is that it doesn't happen and that option of course is much more likely. The option that someone just closes his eyes (you, yours), and doesn't want to have anything to do with it (me), doesn't want the responsibility for affirming you in your being (mine). His affirmation, his want for affirmation looks completely different from yours. And if you won't affirm me, why would I affirm you?

We maintained the dome together for just a short while, the two of us. I rolled in the mud of affirmation like a pig, happy and careless and consequent-free, even if only for a short while. But I was awake all the time, I mean, isn't that what a daydream is all about?

I know some things, yes, I know where his house lives, approximately. Still I see nothing. I see only the past, which I already saw back then, and my dreamed future, which I have seen before just as well. But the now, what happens now, where he is and what he does, I do not see. He's not there.

My earworm turns hysterical. Like a fly banging against the window, unable to leave again. And what has happened to the subtweets? I have lost my talent for ambiguousness. Or rather, looking back and trying to find that glow again, reading my own profile, I see that it is not the subtweet that is ambiguous, but my very own private eye that is, or rather, was.

It was no trouble to you (him) at all to just close your eye on me, right after you opened them.

▶

Inevitably the story turns stale. I want to be angry but I'm not. Maybe just a bit, but only in a rational way, not emotionally. And I'm mostly angry at myself of course. I made a fool out of myself for everyone to see, up to the database. One Wende and there you go. So why am I still talking? I feel cynical, I feel easy. One compliment and architecture is erected. A couple of weeks and it's down again.

I feel easy, easy peasy pleased. Someone looks at me, his wrinkles shift around the eyes, minimally shift the life into the face, and I try to catch the change, again and again and then the shifting of these small movements turns into a leap when the compliment drops out onto the floor, causing the ground to fly up, like the impact of a meteorite, and I knew he was right, that I shouldn't belittle myself. Neither should I do so with him. I didn't. It was not a shortage in affirmation, a hole in the form of a trauma, never to be filled, it was the repeated tracking of movements, again and again, shifting in their minimal ways, shifting life into, me.

Dear Sir, I seek a companion. I seek not sexual arousal (although yes, sure) and I am annoyed that there exists nothing else, apparently. Please do not think lowly of me, do not belittle me, please send me a subtweet that is ambiguous, intellectually stimulating, because my rationally contained emotions will find that pleasing. Give me lust, love and companionship, in reverse order. Do not disappoint me (yet).

▶

Still I keep talking. Why? Is he still watching nonetheless? Or is he listening now? Now that I'm saying this to you –

even though I never had the conviction that you would hear me and it doesn't matter, really – I wonder if there was sound too. I think so, the earworms were there, the songs I sung, the ever repeated verses that accompanied me day in day out and that drew out the dome in the spacetime of three minutes; when I sing them he hears them, he will have heard them. He won't see me singing without any voice will he?

So, does he hear me now? Does he listen to what I'm saying now? No, I think he doesn't, rather he will see me, maybe, somewhere somehow he still sees me. Sitting at the kitchen table, my telephone in front of me, the half empty glass of wine right there at my fingertips, there's the laptop, I'm thinking, it's the pose of the thinker.

He might see, but no, I don't think he hears me. The files are locked in and will not leave the device. They are only allowed to leave when there's a dome to keep them safe. And the dome, the dome is broken down.

Is she dead yet? No. Is he? Perhaps not either. I speak to you of my act of love, my excessive subtweet voice message, to be repeated again and again, somewhere in a past that's become present and contains a possible future, a possible universe, moving slightly forward, shifting time, shifting place, trading places, with you, until you have become me again.

■

2018

REFERENCES

Listed below are some sources. It is an incomplete list.

Introduction by Way of Acknowledgments (or Vice Versa)
The introduction is adapted from a talk given at 'Art-Knowledge #1 Writing Worlds: Debate about Creative Writing in Research', an evening organized by ARIAS, 22 February 2018, Perdu Amsterdam.

Helen Dewitt, *The Last Samurai*, London: Vintage, 2001.

Orit Gat, *How Do We Write when We Write Online*, http://hdwwwwwo.otdac.org/.

My Shadowbook notefile.

A Small Organic Banana: *Phonophilia* in 12 Scenes
First published by De Groene Amsterdammer, 24 June 2015, republished in Zwemmen in de oceaan: Berichten uit een post-digitale wereld, *Amsterdam: De Bezige Bij, 2017.*

Jean Cocteau, *La voix humaine*, Toneelgroep Amsterdam, 2009 (1930).

Louis Couperus, *The Hidden Force*, translated by Paul Vincent, London: Pushkin Press, 2012 (*De stille kracht*, Amsterdam: Em. Querido, 1988 [1900]).

Arnon Grunberg, 'Telefoonseks', Voetnoot, *de Volkskrant*, 3 July 2010.

Byung-Chul Han, *The Transparency Society*, translated by Erik Butler, Stanford: Stanford University Press, 2015 (*Transparenzgesellschaft*, Berlin: Matthes & Seitz, 2012).

E.T.A. Hoffmann, 'Der Sandmann', in *Nachtstücke* (1813), http://www.gutenberg.org/ebooks/6341.

Eva Illouz, *Why Love Hurts: A Sociological Explanation*, Cambridge & Malden: Polity, 2012.

Spike Jonze, *Her*, 2014.

Nathan Jurgenson, 'The Disconnectionists', *The New Inquiry*, 13 November 2013, http://thenewinquiry.com/essays/

the-disconnectionists/.

Dezső Kosztolányi, *Kornél Esti*, translated by Bernard Adams, New York: New Directions, 2011 (1933).

Ben Lerner, *10:04*, New York: Farrar, Straus and Giroux, 2014.

Shadowbook
First published by The Torist, *no. 1, January 2016.*
You may discover the references yourself.

Notes Towards a Spreadsheet Novel
First published by De Internet Gids, *no. 4, August 2016.*

René ten Bos, *Bureaucratie is een inktvis*, Amsterdam: Boom, 2015.

Will Davies, 'The Data Sublime', *The New Inquiry*, 12 January 2015, https://thenewinquiry.com/the-data-sublime/.

Fjodor Dostojevski, *Duivels*, translated into Dutch by Hans Boland, Amsterdam: Athenaeum-Polak & Van Gennep, 2009 (1872).

Paul Ford, 'What is Code', *Businessweek*, 11 June 2015, https://www.bloomberg.com/graphics/2015-paul-ford-what-is-code/.

David Graeber, *The Utopia of Rules: On Technology, Stupidity, and the Secret Joys of Bureaucracy*, Brooklyn & London: Melville House Publishing, 2015.

Julia Hartwig, 'Hoe kun je', translated into Dutch by Gerard Rasch, not published.

Laszlo Krasznahorkai, *Satanstango*, translated into Dutch by Mari Alföldy, Amsterdam: Wereldbibliotheek, 2012 (1985).

Steven Levy, 'A Spreadsheet Way of Knowledge', *Wired Backchannel*, 10 October 2014 (1984), https://www.wired.com/2014/10/a-spreadsheet-way-of-knowledge/.

Tom McCarthy, *Satin Island*, New York: Alfred A. Knopf, 2015.

Raymond R. Panko, 'What We Know About Spreadsheet Errors', Published in the *Journal of End User Computing's*, Spe-

cial issue on Scaling Up End User Development, 10:2 (Spring 1998): 15-21, Revised May 2008, http://panko.shidler.hawaii.edu/SSR/Mypapers/whatknow.htm.

Constant van Wessem, *Celly: Lessen in charleston*, Amsterdam: Em. Querido, 1937 (1931).

Wang Xiaofang, *The Civil Servant's Notebook*, translated by Eric Abrahamsen, Penguin Group (Australia), 2015 (2009).

The Post-digital Condition
First published in Zwemmen in de oceaan: Berichten uit een postdigitale wereld, *Amsterdam: De Bezige Bij, 2017; translation by Nadia Palliser published 18 May 2017*, INC Longform, *http://networkcultures.org/longform/2017/05/18/the-post-digital-condition/.*

Kim Cascone, 'The Aesthetics of Failure: "Post-Digital" Tendencies in Contemporary Computer Music', *Computer Music Journal*, Winter 2000, vol. 24.

Florian Cramer, 'What is Post-digital?', *APRJA*, http://www.aprja.net/?p=1318.

Fyodor Dostoevsky, *Demons*, translated by Richard Pevear and Larissa Volokhonsky, London: Vintage Books, 1994.

Maarten van der Graaff, 'Nachtploeg – Eens was ze veraf', *ooteoote*, 3 januari 2012, http://ooteoote.nl/2012/01/nachtploeg-2/.

Maarten van der Graaff, *Dood werk*, Amsterdam: Atlas Contact, 2015.

Maarten van der Graaff, 'Druk op huid', juni 2015, http://n30.nl/blog/druk-op-huid/.

Kavita Hayton, 'New Expressions of the Self: Autobiographical Opportunities on the Internet', *Journal of Media Practice* volume 10 numbers 2&3, 2009.

Sheila Heti, *How Should a Person Be?*, Toronto: House of Anansi Press, 2012.

Sheila Heti, 'My Life Is a Joke', *The New Yorker*, 11 May 2015, http://www.newyorker.com/magazine/2015/05/11/my-life-is-

a-joke.

Karl Ove Knausgård, *Some Rain Must Fall: My Struggle Book Five*, translated by Don Bartlett, New York: Archipelago Books, 2016. Book Six is not translated into English yet, translation of the quote by Miriam Rasch.

Alessandro Ludovico, *Post-digital Print: The Mutation of Publishing Since 1894*, Eindhoven: Onomatopee, 2012.

'MTV Made', *Wikipedia*, https://en.wikipedia.org/wiki/Made_(TV_series).

David Shields, *Reality Hunger: A Manifesto*, New York: Knopf, 2010.

Maartje Wortel, *Er moet iets gebeuren*, Amsterdam: Das Mag, 2015.

40: A Fictitious Smartphone Essay on Friendship
First published as De Internet Gids Cahier, *no 3, November 2017.*

Benjamin Grosser, 'Facebook Demetricator', http://bengrosser.com/projects/facebook-demetricator/.

Barbara Hannah Grufferman, '5 Life-Changing Events That Can Shake Us to Our Core', *Huffpost*, 5 November 2013, http://www.huffingtonpost.com/barbara-hannah-grufferman/turning-50_b_4181486.html.

Britta Hausmann, 'Wir fangen neu an', *Frankfurter Allgemeine*, 26 December 2016, http://www.faz.net/aktuell/gesellschaft/menschen/ein-neuer-anfang-beste-freundschaft-mit-siebenjaehriger-pause-14583920.html.

'Marc Augé', *Wikipedia*, https://nl.wikipedia.org/wiki/Marc_Augé.

Alana Massey, 'The Clique Imaginary', *The New Inquiry*, 26 May 2016, https://thenewinquiry.com/the-clique-imaginary/.

Hito Steyerl, 'The Terror of Total Dasein', http://dismagazine.com/discussion/78352/the-terror-of-total-dasein-hito-steyerl/.

This American Life, '573: Status Update', 27 November 2015, https://m.thisamericanlife.org/radio-archives/epi-

sode/573/status-update.

Vera Tollmann, 'The Terror of Positivity, Interview with Byung-Chul Han', *springer|in*.

Era Ziesk, 'Thankful for Such Friends', *The Millions*, 21 November 2012, http://themillions.com/2012/11/thankful-for-such-friends.html.

Ben Zimmer, 'The Rise of the Zuckerverb: The New Language of Facebook', *The Atlantic*, 30 September 2011, https://www.theatlantic.com/technology/archive/2011/09/the-rise-of-the-zuckerverb-the-new-language-of-facebook/.

SUBLIMINALITATIONS

A lot of sources have been poured into this text, but almost all of them were removed again (except for the letter of Bruno Schulz to Tadeusz Breza and the poem 'Vers 4' by Paul van Ostaijen), leaving their traces on various levels of distinguishability.

 www.ingramcontent.com/pod-product-compliance
Lightning Source LLC
Chambersburg PA
CBHW052319220526
45472CB00001B/187